Cute Drawings

474 Fun Exercises to Draw Everything Cuter

Yooco Takashima

Introduction

Hello! My name is Yooco Takashima, and I'm an illustrator. Thank you very much for choosing this book.

Illustrations soften your heart, make you laugh, and add color to your life. First, just grab the nearest pen and give drawing a try! Liven up your planner and you'll find it's fun to look at your schedule. Decorate a missed call note and you'll make your coworker happy. You can also convey your feelings with a cute card...
Don't worry too much—just think, "Well as long as I'm writing this anyways," and start drawing. Once you get used to doing this, you can create your own customized goods. Adding even a little bit of illustration to your life makes every day more fun. This book has spaces to practice drawing. Learn the techniques for each drawing as you go.

Then, once you can use them, start drawing the illustrations in your own way. The more you draw, the more you'll improve. I hope this book helps you fill your life with fun illustrations.

Contents

CHAPTER 01
People & Living Things

CHAPTER 02
Plants & Food

CHAPTER 03
Everyday Items

CHAPTER 04
And More!

*Some illustrations might not seem to fit in their categories, but I've introduced them in a way that's easier to understand.

Before You Begin

1 Start with little drawings in the corner of your notebook.

First, draw little things in the margins of your notebook or on memos. Don't try too hard— draw freely. It's important to have fun.

Start easy.

I did it!

2 Draw simple pictures first.

Start with really easy things that you're sure you can draw. Once you get used to drawing those, other pictures that seemed hard at first will start to feel doable and you'll find you want to try drawing them.

3 Observe closely.

Observation is crucial for drawing! For example, if you want to draw your pet bird, first you need to observe him carefully. His round head, his tail sticking straight out, his color... Put those details in your picture.

Hmm, hmm...

4 Keep practicing.

In order to get good at drawing, you have to draw a lot and get used to it! I recommend drawing each picture over and over. Carve out a little time each day to practice and you're sure to improve.

Enjoy drawing!

\ Choosing the Ballpoint Pens /

Thickness

The impression your illustrations make changes depending on the thickness of the lines. Choose a thickness that works for the picture you want to draw. In this book, I used mostly 0.5 mm pens.

 0.3mm

This is a good thickness for adding details.

 0.5mm

Allows you to draw moderately thick lines smoothly.

 0.7mm

Quite thick. I use these to add color.

 1.0mm

Creates a soft touch. Not good for detail work.

Color

Ballpoint pens come in lots of colors besides the usual black, red, and blue! Try them out at the store, find your favorites, and enjoy creating colorful pictures. In this book I use these twelve colors on the right.

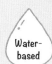

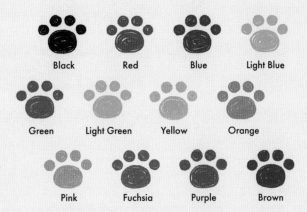

Black Red Blue Light Blue

Green Light Green Yellow Orange

Pink Fuchsia Purple Brown

Ink Type

Ballpoint pens mainly use one of the three ink types on the right. They're all different, so you should consider which ink works for your project. Some will smudge if you touch your picture right after drawing, so be careful.

Water-based
This type is not very sticky, so you can draw smooth lines with no globs. The colors are vibrant, but this ink is sensitive to water. If you get it wet, it will bleed and possibly seep through to the back.

Oil-based
This ink is sticky, so it's very durable. It doesn't bleed or seep, but the colors are less vibrant, and globs tend to form.

Gel-based
Ink that combines the good points of water- and oil-based types. It doesn't bleed easily and the tip of your pen seems to glide. The colors come out lovely and vibrant.

Drawing Basics

Use Shapes

Simple shapes like circles, triangles, squares and rectangles; dots and zigzags; swirls, symbols, and borders... When you place these together and combine them, then add a few extra touches, creating cute illustrations is a piece of cake.

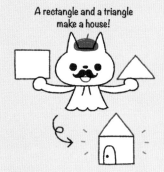

A rectangle and a triangle make a house!

Use circles...

Smile!

Sun

Use triangles...

Rice ball

Butterfly

Use rectangles...

Letter

Present

Put them together...

Light bulb

How to Color

There are a few ways to add color with a ballpoint pen. By coloring your pictures, it brightens them up and gives them texture. Color takes your illustrations to the next level. And by changing the coloring technique, you can change their feel.

Coloring is part of illustrating too!

In one direction

Good for straight-edged shapes like squares and triangles.

Swirls

Good for curved shapes and creating fluffy texture.

Lines	Dots	Checks	Offset

Using Areas and Lines

You can use lines or areas to express color. Lines are simple and clean, while areas add brightness and impact. Try drawing with just lines, just areas, and a mixture of both.

How should I draw this?

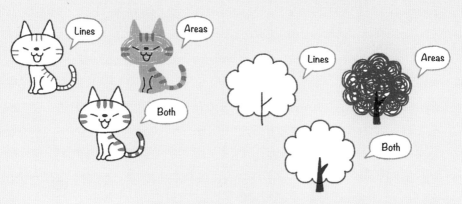

Lines

Areas

Both

Lines

Areas

Both

Color Scheme

You can refer to real colors or dare to use different ones—it's up to you. When combining colors, decide if you want to create a similar image or use complementary color... Try not to use too many though as it starts to get busy, so a three-color limit is key.

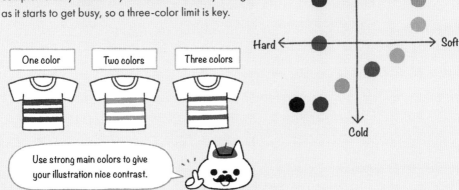

One color

Two colors

Three colors

Use strong main colors to give your illustration nice contrast.

Color Image

Warm

Hard ← → Soft

Cold

7

How to Use This Book

STEP 1 First, take a look at the finished illustrations.

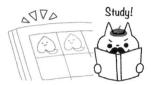

Study!

STEP 2 Next, try tracing the gray drawing.

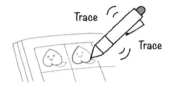

Trace

Trace

STEP 3 Then try drawing it on your own in the practice spaces. Draw as many pictures as there are spaces.

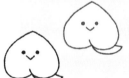

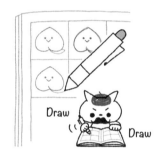

TIP

You don't have to use the same colors as the finished illustrations. It's also fine to draw in just black. You'll get the hang of it as you go.

Draw

Draw

STEP 4 Once you have learnt to draw a picture, use it in your notebook or on memos—anywhere you like. The more you draw, the more fun it gets!

hello!

Variations!

When you see the "Variations" mark...

In the Variations! section, I'll introduce simple ways to redesign the illustrations by just changing the shape a little bit or using a different color. Look at these while trying to come up with your own variations, too.

CHAPTER 01

⬇

People & Living Things

Dogs and cats, bunnies, pandas, bears...
First, try drawing your favorite animal.
People all have the same basic face with
simple variations.

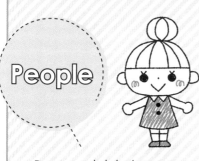

People

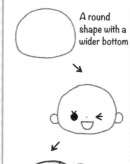

Drawing a whole body is pretty tricky, so let's start by mastering the face. Begin with the outline.

A round shape with a wider bottom

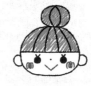

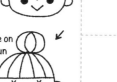

Put a circle on top for a bun

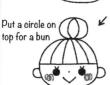

Variations!

Try coloring in the hair

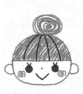

Try making the bun a swirl

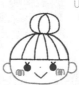

Use a color similar to real hair

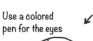

Use a colored pen for the eyes

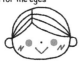

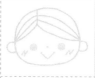

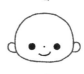

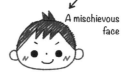

A mischievous face

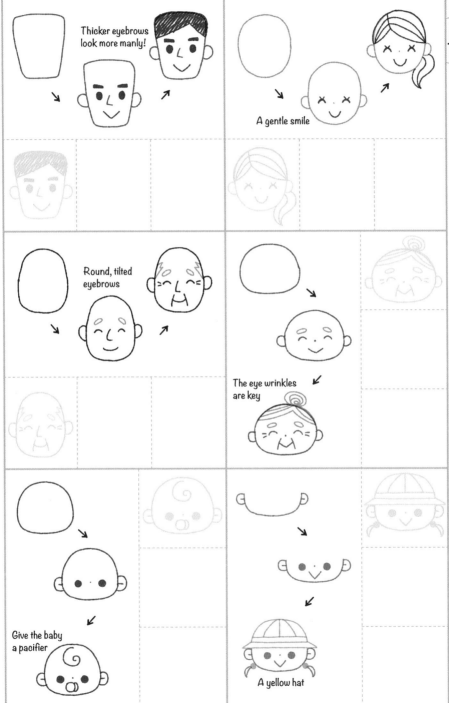

Thicker eyebrows look more manly!

A gentle smile

Round, tilted eyebrows

The eye wrinkles are key

Give the baby a pacifier

A yellow hat

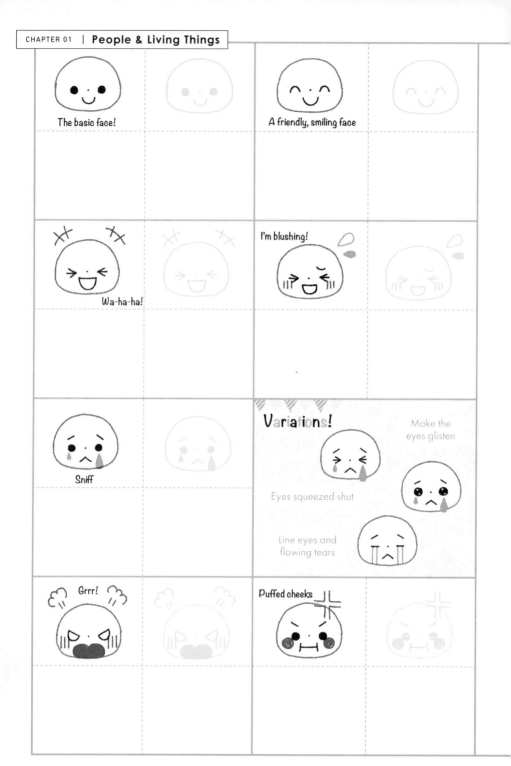

The basic face!

A friendly, smiling face

Wa-ha-ha!

I'm blushing!

Sniff

Variations!

Make the eyes glisten

Eyes squeezed shut

Line eyes and flowing tears

Grrr!

Puffed cheeks

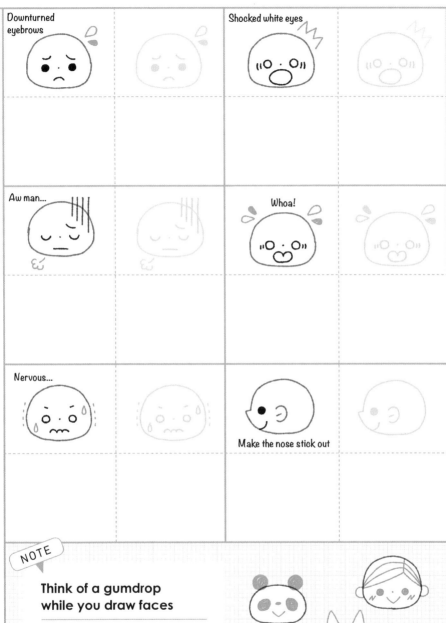

Downturned eyebrows

Shocked white eyes

Aw man...

Whoa!

Nervous...

Make the nose stick out

NOTE

Think of a gumdrop while you draw faces

A simple way to make people and animal faces look cuter is to draw an oval outline, and then, you know how a gumdrop is more filled out at the bottom? Try doing that to your ovals.

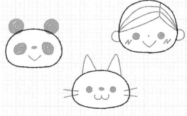

Draw the oval first, then add the eyes, nose, mouth, and ears. Make the outlines for people taller so you can add hair.

Add small swirls

Dots for
a shaved head

Make rows of circles

Glasses, then the eyes

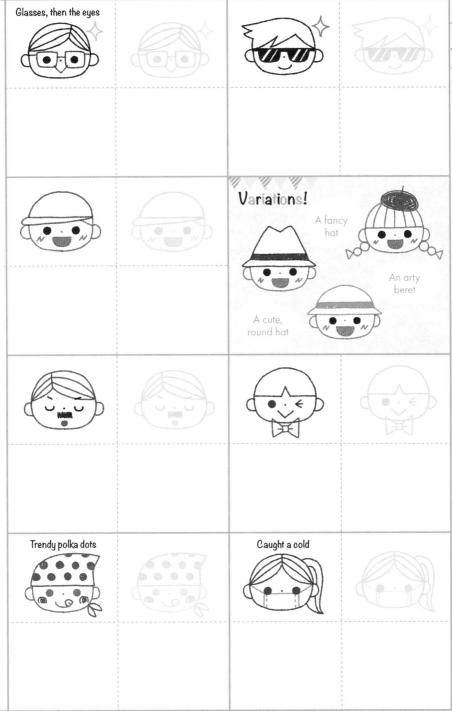

Variations!

A fancy hat

An arty beret

A cute, round hat

Trendy polka dots

Caught a cold

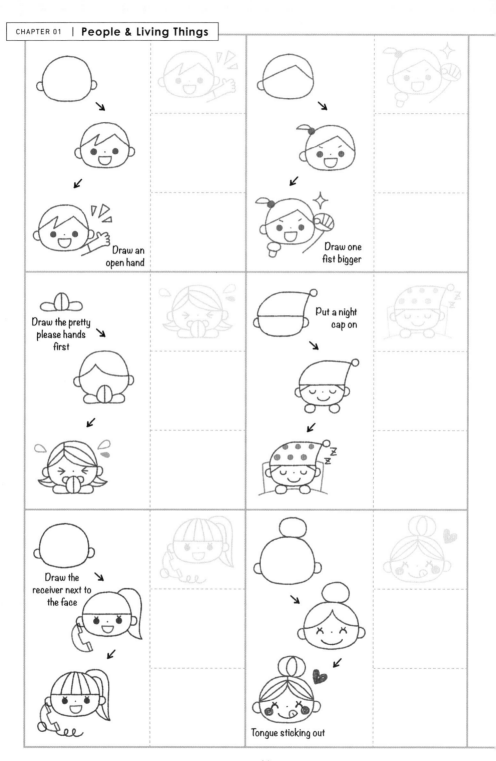

Draw an open hand

Draw one fist bigger

Draw the pretty please hands first

Put a night cap on

Draw the receiver next to the face

Tongue sticking out

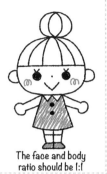

The face and body ratio should be 1:1

NOTE

Making a distinction between adults and kids, guys and girls

The key to making a distinction between adults and kids is the placement of their features. Little boys and girls are especially hard, so use hairstyles, eyelashes, and objects.

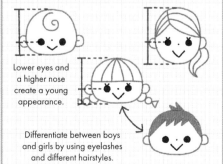

Lower eyes and a higher nose create a young appearance.

Differentiate between boys and girls by using eyelashes and different hairstyles.

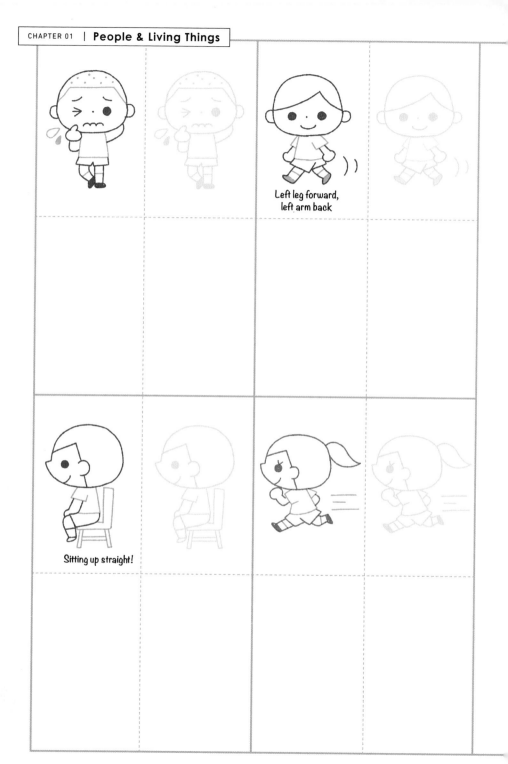

Left leg forward,
left arm back

Sitting up straight!

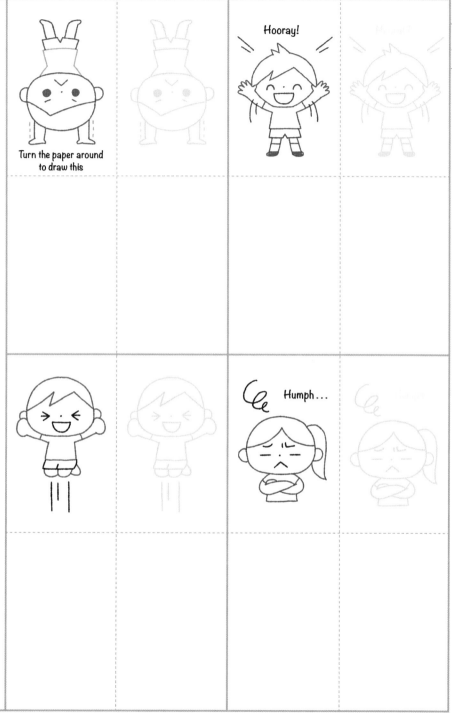

Turn the paper around to draw this

Hooray!

Humph...

Rock!

Scissors!

Paper!

Note!

This way!

Separate the fingers with lines

Make a circle

A heart shape

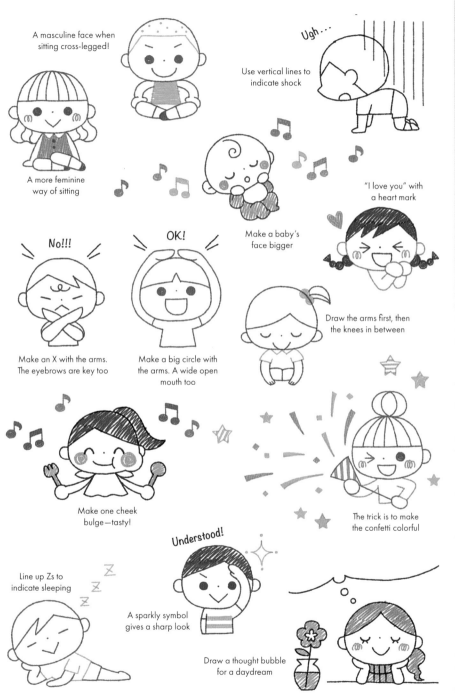

A masculine face when sitting cross-legged!

A more feminine way of sitting

Ugh...

Use vertical lines to indicate shock

"I love you" with a heart mark

Make a baby's face bigger

No!!!

Make an X with the arms. The eyebrows are key too

OK!

Make a big circle with the arms. A wide open mouth too

Draw the arms first, then the knees in between

Make one cheek bulge—tasty!

The trick is to make the confetti colorful

Line up Zs to indicate sleeping

Understood!

A sparkly symbol gives a sharp look

Draw a thought bubble for a daydream

21

Animals

Start with familiar animals like dogs and cats. Pick the distinctive characteristics of each animal and draw them as simply as possible.

Triangle ears

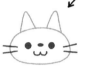

Make the mouth cute

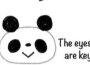
The eyes are key

Round ears

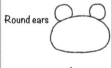

Variations!

Use an area of color instead of an outline

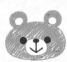
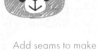
Add seams to make a teddy bear

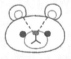

Lose the circle around the nose for a simple look

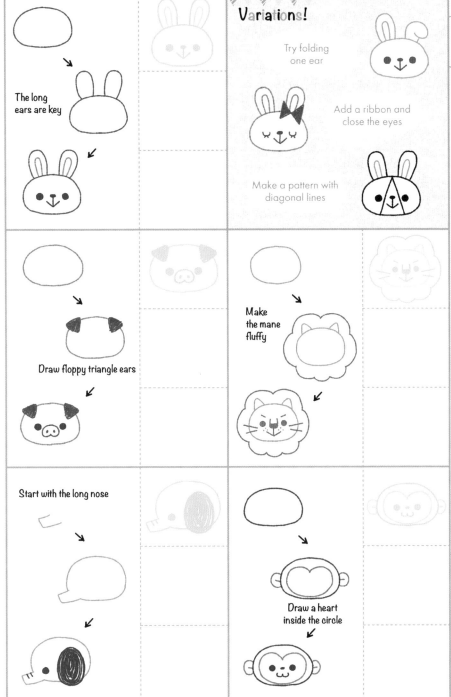

The long ears are key

Variations!

Try folding one ear

Add a ribbon and close the eyes

Make a pattern with diagonal lines

Draw floppy triangle ears

Make the mane fluffy

Start with the long nose

Draw a heart inside the circle

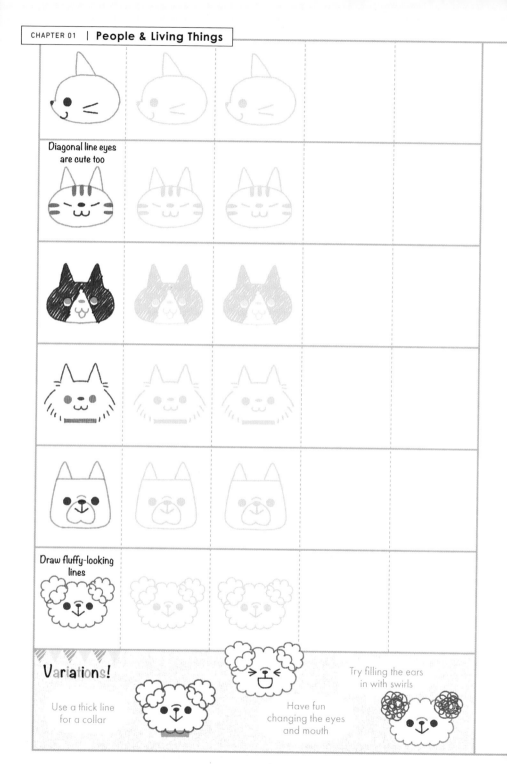

Diagonal line eyes
are cute too

Draw fluffy-looking
lines

Variations!

Use a thick line
for a collar

Have fun
changing the eyes
and mouth

Try filling the ears
in with swirls

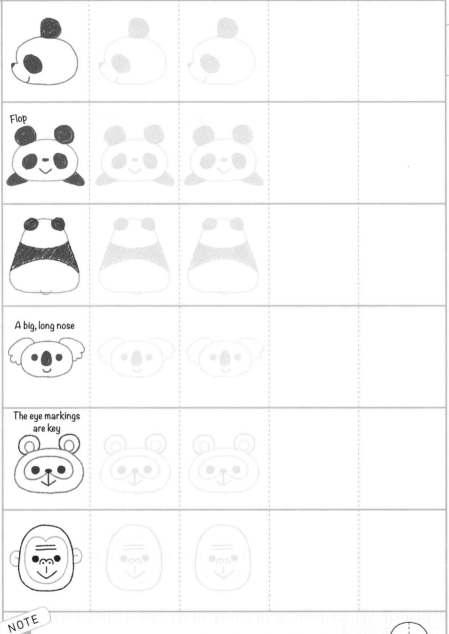

Flop

A big, long nose

The eye markings are key

NOTE

How can we change the direction of the face?

Imagine a ball! If you draw guiding lines with a pencil, it's easy to make your characters look to the side or in any angle.

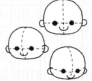

Don't forget the whiskers

A long, thin tail

Draw curvy body lines

Variations!

Make a tabby cat by adding stripes in places

Add facial markings with diagonal lines

Round ears and tail

Sitting straight up

Draw a thick line for a collar to add accent

Tail sticking out

Draw fluffy-looking lines to make soft fur

The basic body shape is the same as a normal dog (left)

The mouth, ears, and tummy markings are key

Head to body ratio is about 1:1

Cute plump body

Use dark and light colors to create a black and white image

Fill the eyes out at the bottom

Pudgy round body

26

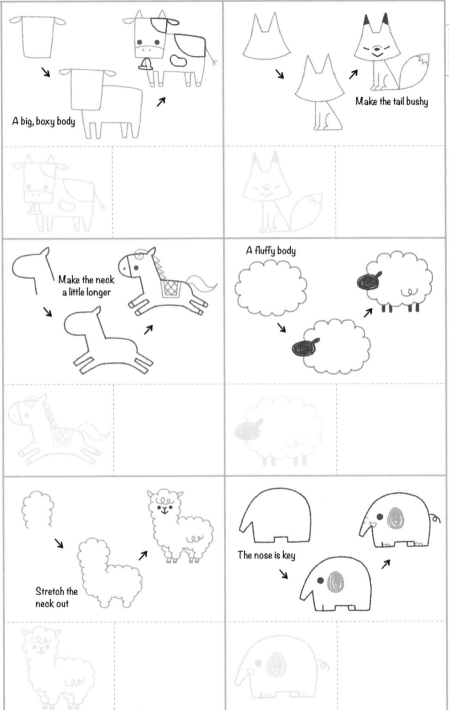

A big, boxy body

Make the tail bushy

Make the neck a little longer

A fluffy body

Stretch the neck out

The nose is key

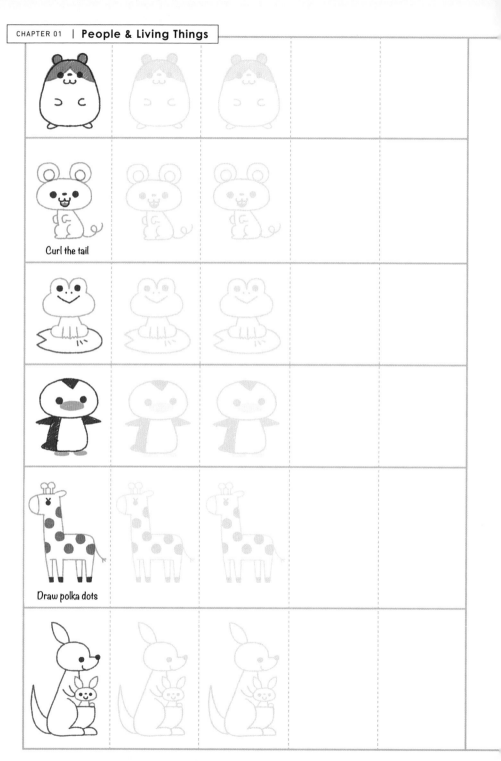

Curl the tail

Draw polka dots

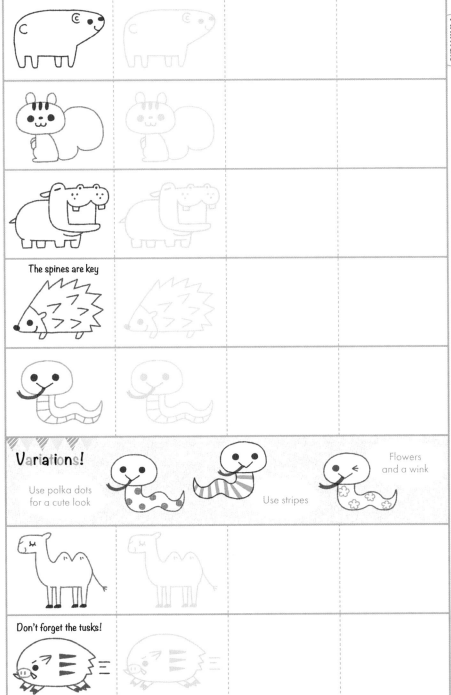

The spines are key

Variations!

Use polka dots
for a cute look

Use stripes

Flowers
and a wink

Don't forget the tusks!

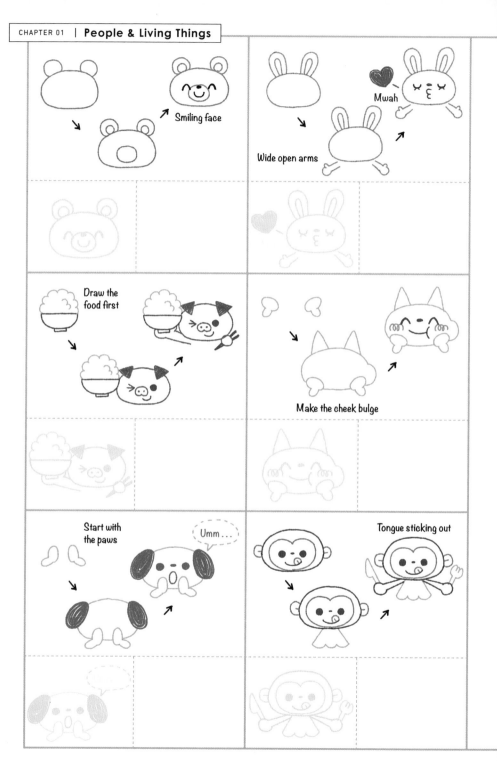

Smiling face

Mwah

Wide open arms

Draw the food first

Make the cheek bulge

Start with the paws

Umm...

Tongue sticking out

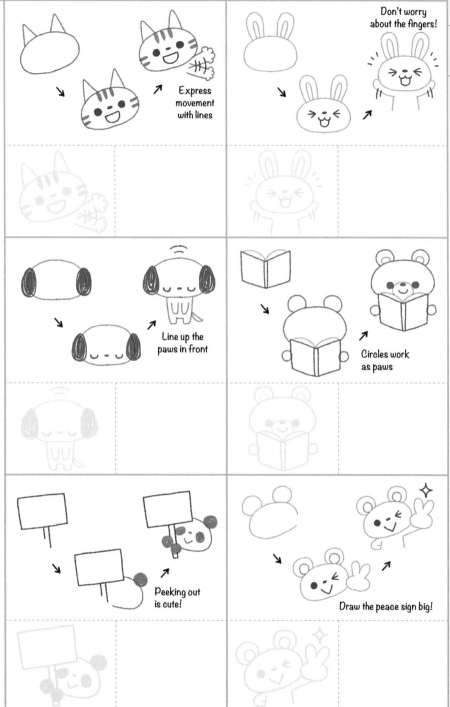

Express movement with lines

Don't worry about the fingers!

Line up the paws in front

Circles work as paws

Peeking out is cute!

Draw the peace sign big!

31

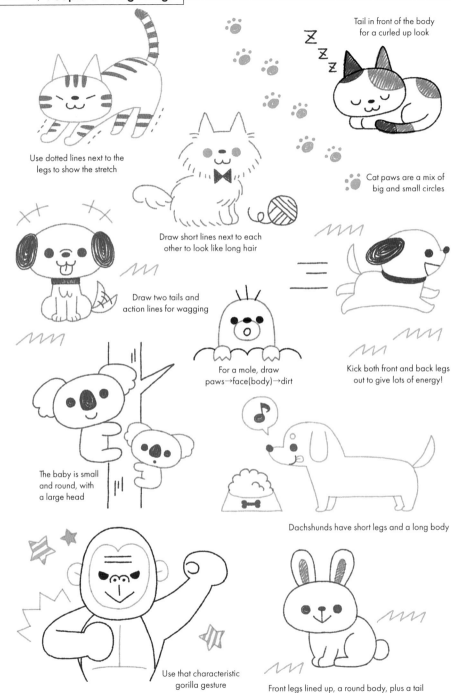

Tail in front of the body
for a curled up look

Use dotted lines next to the
legs to show the stretch

Cat paws are a mix of
big and small circles

Draw short lines next to each
other to look like long hair

Draw two tails and
action lines for wagging

For a mole, draw
paws→face(body)→dirt

Kick both front and back legs
out to give lots of energy!

The baby is small
and round, with
a large head

Dachshunds have short legs and a long body

Use that characteristic
gorilla gesture

Front legs lined up, a round body, plus a tail

32

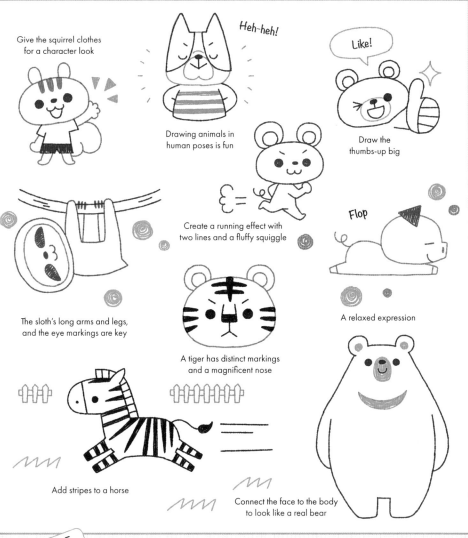

Give the squirrel clothes for a character look

Heh-heh!

Like!

Drawing animals in human poses is fun

Draw the thumbs-up big

Create a running effect with two lines and a fluffy squiggle

Flop

A relaxed expression

The sloth's long arms and legs, and the eye markings are key

A tiger has distinct markings and a magnificent nose

Add stripes to a horse

Connect the face to the body to look like a real bear

NOTE

Try turning animals into characters!

If you put your animals in clothes and draw them doing human gestures, you can turn them into characters. Try giving them all kinds of facial expressions, too.

Yay!

Aquatic Life

Fish, crab, jellyfish, dolphins...
animals that live in oceans and rivers.
The fish seem more real when you
draw their fins.

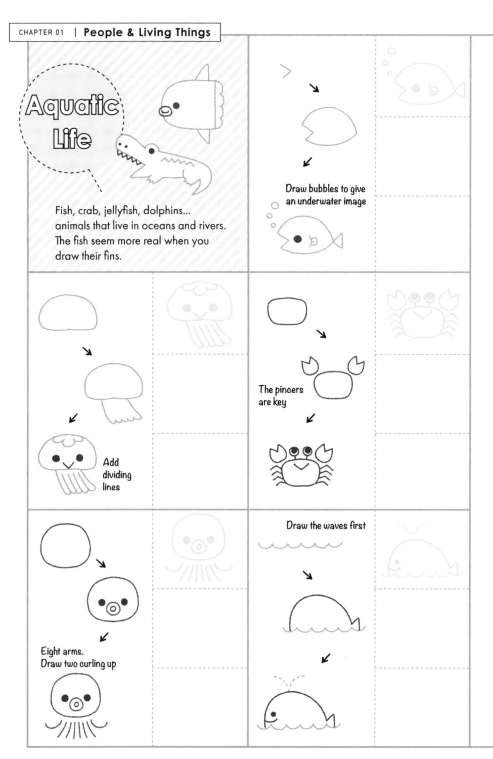

Draw bubbles to give
an underwater image

Add
dividing
lines

The pincers
are key

Eight arms.
Draw two curling up

Draw the waves first

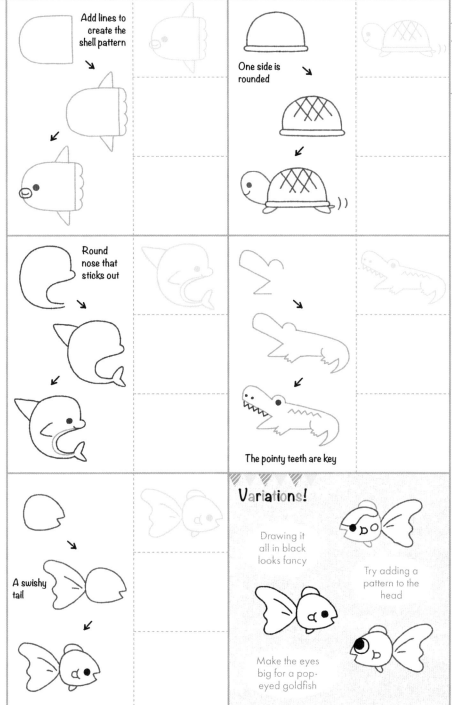

Add lines to create the shell pattern

One side is rounded

Round nose that sticks out

The pointy teeth are key

A swishy tail

Variations!

Drawing it all in black looks fancy

Try adding a pattern to the head

Make the eyes big for a pop-eyed goldfish

35

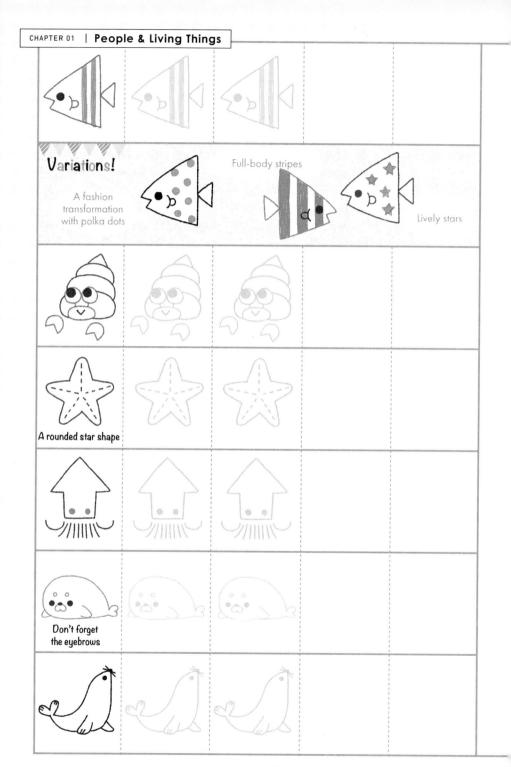

Variations!

A fashion transformation with polka dots

Full-body stripes

Lively stars

A rounded star shape

Don't forget the eyebrows

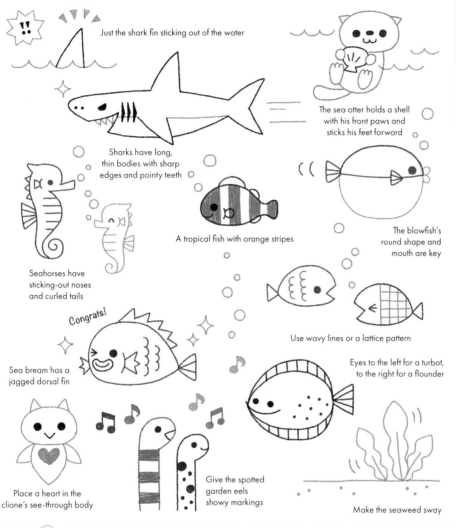

Just the shark fin sticking out of the water

The sea otter holds a shell with his front paws and sticks his feet forward

Sharks have long, thin bodies with sharp edges and pointy teeth

A tropical fish with orange stripes

The blowfish's round shape and mouth are key

Seahorses have sticking-out noses and curled tails

Congrats!

Sea bream has a jagged dorsal fin

Use wavy lines or a lattice pattern

Eyes to the left for a turbot, to the right for a flounder

Place a heart in the clione's see-through body

Give the spotted garden eels showy markings

Make the seaweed sway

NOTE

Exaggerating essential features makes pictures more fun

When drawing animals, it's important to understand their main characteristics. If you exaggerate them a little bit, it's easier to tell what animal it is.

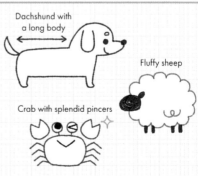

Dachshund with a long body

Fluffy sheep

Crab with splendid pincers

Bugs

You can draw lovable bugs by leaving out details, drawing them as simply as possible.

Use triangles for the wings

Line up two circles

Variations!

No outlines and color in with swirls

Add lines to form a pattern

Create a cute look with polka dots

Draw seven spots

Stripes

38

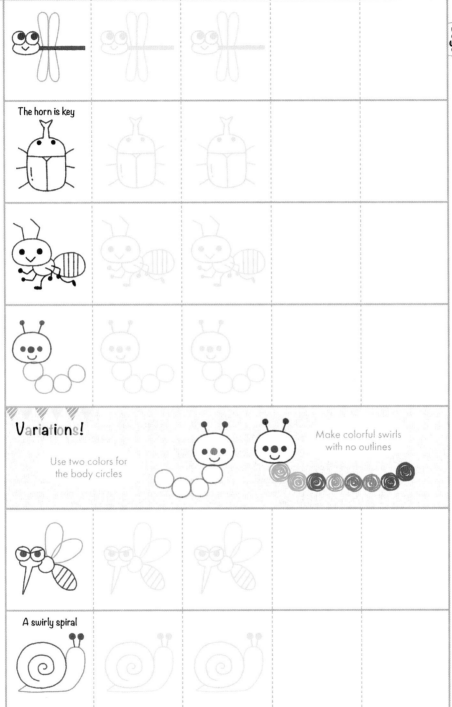

The horn is key

Variations!

Use two colors for
the body circles

Make colorful swirls
with no outlines

A swirly spiral

Birds

Start with a bird that is more like an icon, then learn specific types.

Semi-circle wing and triangle tail

A round gumdrop shape

A big circle and a little circle

Use a line for the legs

Variations!

Add feet and action lines to make it walk

Try putting a letter in its beak

Smiling eyes to present a flower

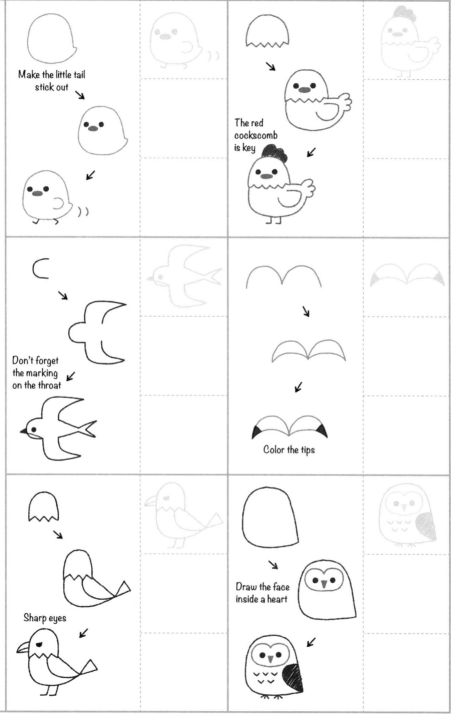

Make the little tail stick out

The red cockscomb is key

Don't forget the marking on the throat

Color the tips

Sharp eyes

Draw the face inside a heart

41

Cockatiel

Parrot

Plump tummy

The shape of the wings is key

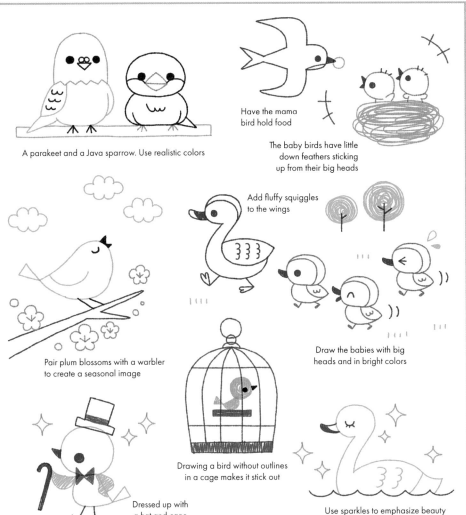

A parakeet and a Java sparrow. Use realistic colors

Have the mama bird hold food

The baby birds have little down feathers sticking up from their big heads

Add fluffy squiggles to the wings

Pair plum blossoms with a warbler to create a seasonal image

Draw the babies with big heads and in bright colors

Dressed up with a hat and cane

Drawing a bird without outlines in a cage makes it stick out

Use sparkles to emphasize beauty

 NOTE

Add more expression with emotion symbols

Try adding emotion symbols like the kind that appear in comics. It'll add a lot of feeling to your drawings. It goes without saying that you can add them to people and animals, but it's even fun to add them to objects!

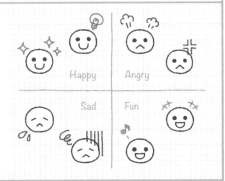

Happy Angry

Sad Fun

Symbols

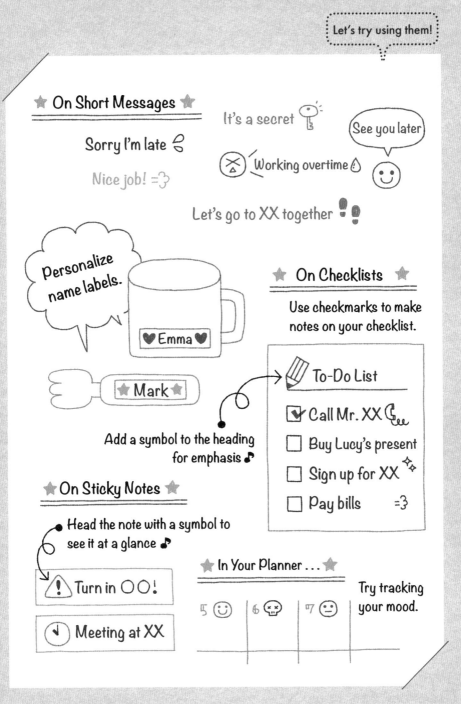

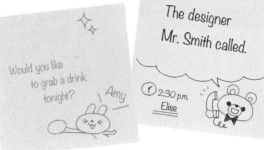

Thanks for today!
Come over again
sometime.

Cathy

Note

Add illustrations to notes for people at work or on invitations. The receiver is sure to love it.

Cards

Write a message on a card cut in a shape that fits the occasion. Make animals easy to relate to by adding expressions.

Business Cards

Draw something you like as a frame for your card. People are sure to remember your originality.

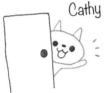

Let's go here together!!!

I want this.

Recommended

You gotta see this!

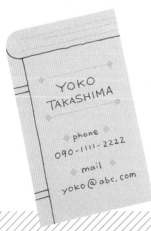

YOKO
TAKASHIMA

phone
090-1111-2222

mail
yoko@abc.com

Sticky Notes

Draw an animal or person's face at the top and cut along the outline. It's cute to have the faces peeking out from where you stick them.

Plants & Food

Flowers, trees, and food are common
themes. Create simple drawings without
too many details that become cute,
easy illustrations.

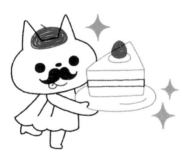

Flowers

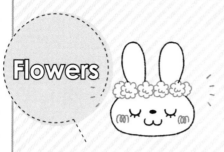

Flowers are one easy motif to draw. Even if the lines are a little crooked or the shape is distorted, they are still recognizable.

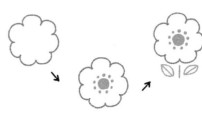

Dots around a circle

Use a fluffy line to represent small flower petals

The petal tips are key

Draw diagonal lines

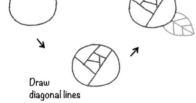

Variations!

Use a colored area to create a bright image

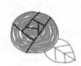

Try adding a stem and a glass

Wrap it up in paper and a bow

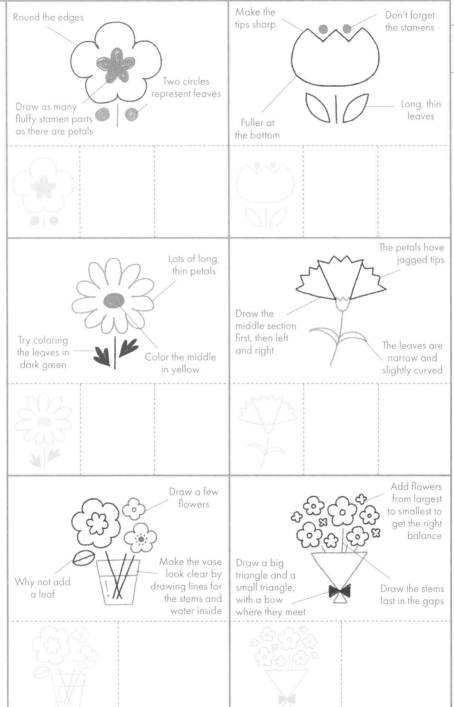

Round the edges

Draw as many fluffy stamen parts as there are petals

Two circles represent leaves

Make the tips sharp

Don't forget the stamens

Fuller at the bottom

Long, thin leaves

Lots of long, thin petals

Try coloring the leaves in dark green

Color the middle in yellow

The petals have jagged tips

Draw the middle section first, then left and right

The leaves are narrow and slightly curved

Draw a few flowers

Why not add a leaf

Make the vase look clear by drawing lines for the stems and water inside

Add flowers from largest to smallest to get the right balance

Draw a big triangle and a small triangle, with a bow where they meet

Draw the stems last in the gaps

49

Hibiscus

Small flowers inside
a circle

Round petals

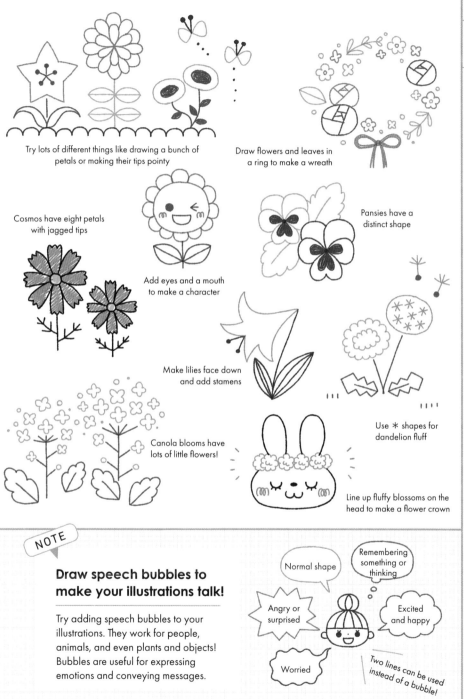

Try lots of different things like drawing a bunch of petals or making their tips pointy

Draw flowers and leaves in a ring to make a wreath

Cosmos have eight petals with jagged tips

Add eyes and a mouth to make a character

Pansies have a distinct shape

Make lilies face down and add stamens

Use ✳ shapes for dandelion fluff

Canola blooms have lots of little flowers!

Line up fluffy blossoms on the head to make a flower crown

NOTE

Draw speech bubbles to make your illustrations talk!

Try adding speech bubbles to your illustrations. They work for people, animals, and even plants and objects! Bubbles are useful for expressing emotions and conveying messages.

Normal shape

Remembering something or thinking

Angry or surprised

Excited and happy

Worried

Two lines can be used instead of a bubble!

Trees & Foliage

Trees and leaves, houseplants, mushrooms, and acorns may not be flowers, but they still work as charming motifs.

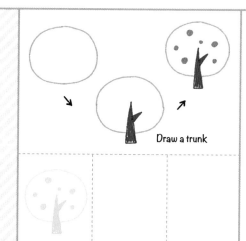

Draw a trunk

Variations!

Try drawing an area with a swirl of green

Draw with pink swirls for cherry blossoms

A long, thin triangle gives a sharp image

An oval is cute, too

Draw yellow swirls for autumn leaves

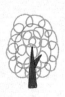

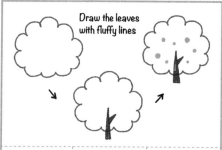

Draw the leaves with fluffy lines

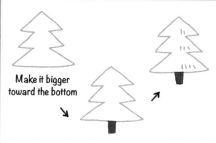

Make it bigger toward the bottom

52

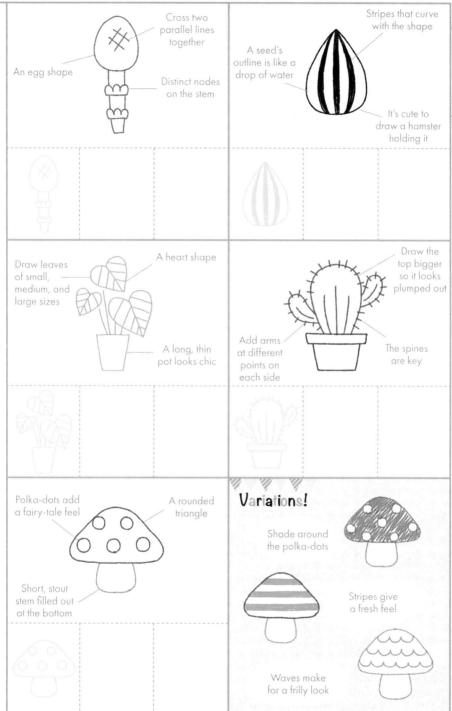

An egg shape

Cross two parallel lines together

Distinct nodes on the stem

A seed's outline is like a drop of water

Stripes that curve with the shape

It's cute to draw a hamster holding it

Draw leaves of small, medium, and large sizes

A heart shape

A long, thin pot looks chic

Draw the top bigger so it looks plumped out

Add arms at different points on each side

The spines are key

Polka-dots add a fairy-tale feel

A rounded triangle

Short, stout stem filled out at the bottom

Variations!

Shade around the polka-dots

Stripes give a fresh feel

Waves make for a frilly look

Variations!

Try roughly coloring the area light green

A missing piece makes it a fallen leaf

Equal on both sides

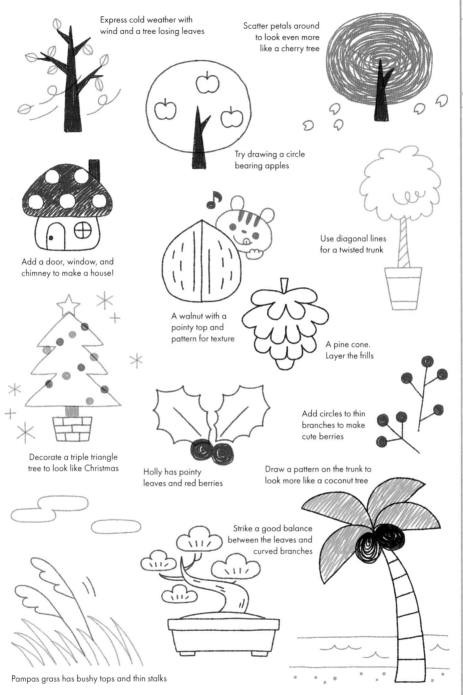

Express cold weather with wind and a tree losing leaves

Scatter petals around to look even more like a cherry tree

Try drawing a circle bearing apples

Add a door, window, and chimney to make a house!

A walnut with a pointy top and pattern for texture

A pine cone. Layer the frills

Use diagonal lines for a twisted trunk

Add circles to thin branches to make cute berries

Decorate a triple triangle tree to look like Christmas

Holly has pointy leaves and red berries

Draw a pattern on the trunk to look more like a coconut tree

Strike a good balance between the leaves and curved branches

Pampas grass has bushy tops and thin stalks

Fruits & Vegetables

Fruits and veggies, with their adorable shapes, are great for decoration. They're also easy to draw.

Draw the seeds

Add a leaf

Variations!

Leave a spot uncolored to make it shiny

Use light green for a green apple!

Draw two seeds for an apple cut in half

Add shine to look yummy

A triangle with a round base

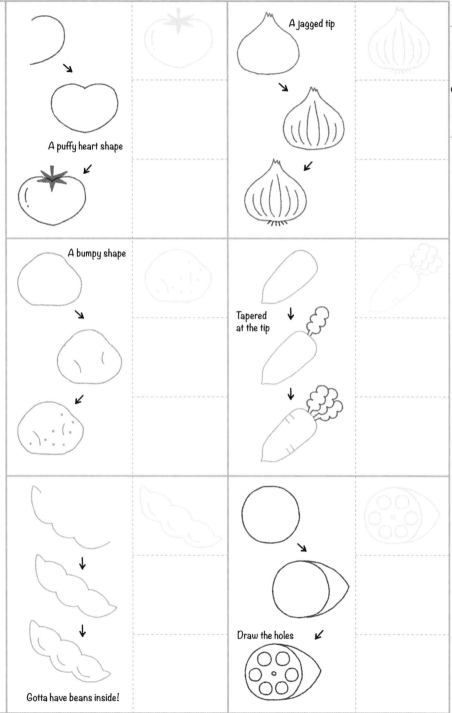

A puffy heart shape

A jagged tip

A bumpy shape

Tapered at the tip

Gotta have beans inside!

Draw the holes

57

A chic cut-away

The pattern is key

Use crosshatch for the pattern

Line up lots of circles

Variations!

Use light green for green grapes!

Try coloring them in with swirls

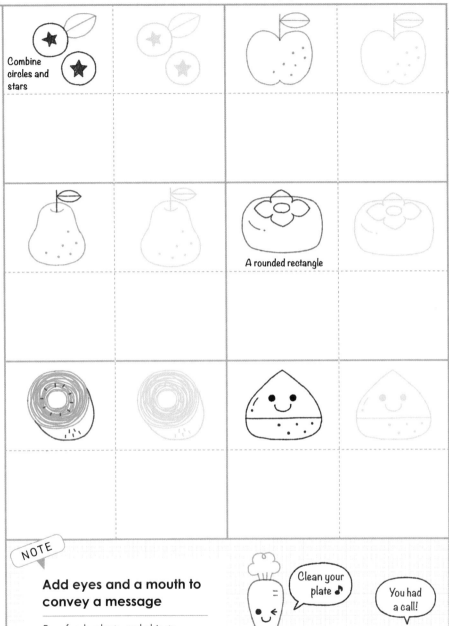

Combine circles and stars

A rounded rectangle

NOTE

Add eyes and a mouth to convey a message

Even foods, plants, and objects transform into characters when you draw a face. Put extra feeling into your message by using a speech bubble.

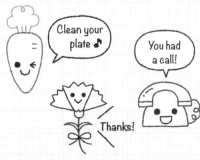

Clean your plate ♪

You had a call!

Thanks!

A long, rounded triangle

Red for spice

Add a rough pattern

A face makes it easier to get along with vegetables you don't like

Draw sparkles to make them look juicy

Draw the prickles as dots

Make folded layers

Indicate the kernels with crosshatch

The wave and triangle patterns are key

Add some hairs to a long, thin shape with a pointy end to make a burdock root

A radish is cute like a heart

Draw lots of them to look more real

Color leeks green just to partway down

Perilla leaves have jagged edges

A *shiitake* has a wide cap and a long stem

Trumpet mushrooms have flat tops and reveal what's under their caps

Add an expression, arms, and legs to show real energy!

The cut edge of okra looks like a star. Don't forget to draw the seeds

A zigzag pattern is key for watermelons

Light and leafy on top, heavy on the bottom

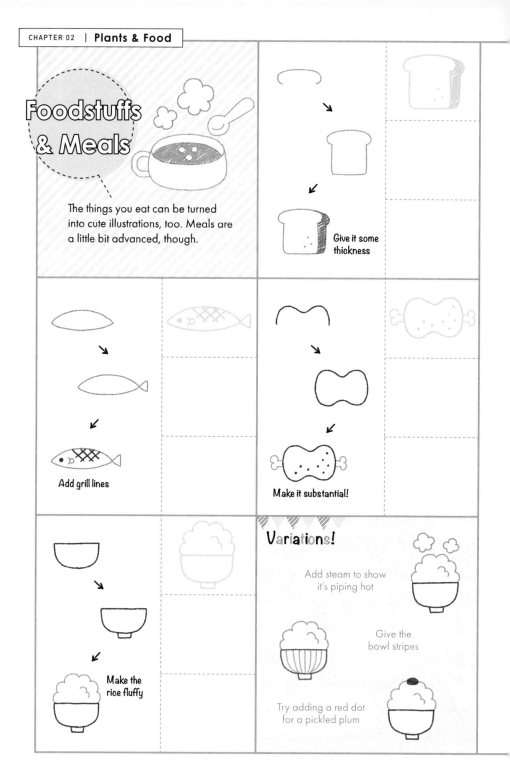

Foodstuffs & Meals

The things you eat can be turned into cute illustrations, too. Meals are a little bit advanced, though.

Give it some thickness

Add grill lines

Make it substantial!

Make the rice fluffy

Variations!

Add steam to show it's piping hot

Give the bowl stripes

Try adding a red dot for a pickled plum

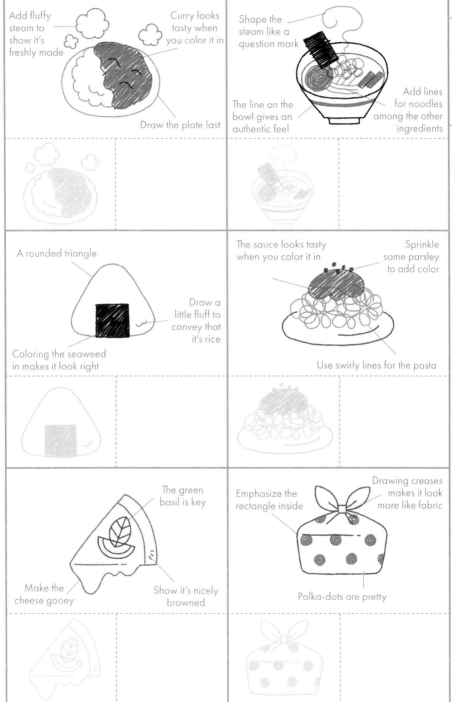

Add fluffy steam to show it's freshly made

Curry looks tasty when you color it in

Draw the plate last

Shape the steam like a question mark

The line on the bowl gives an authentic feel

Add lines for noodles among the other ingredients

A rounded triangle

Draw a little fluff to convey that it's rice

Coloring the seaweed in makes it look right

The sauce looks tasty when you color it in

Sprinkle some parsley to add color

Use swirly lines for the pasta

The green basil is key

Make the cheese gooey

Show it's nicely browned

Emphasize the rectangle inside

Drawing creases makes it look more like fabric

Polka-dots are pretty

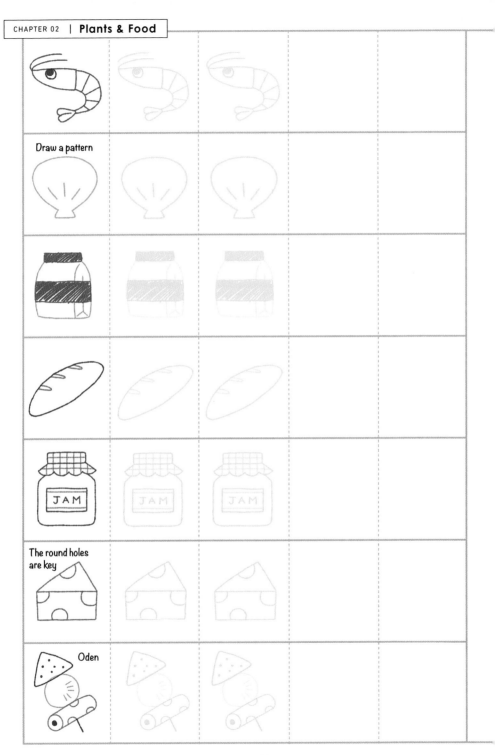

Draw a pattern

The round holes are key

Oden

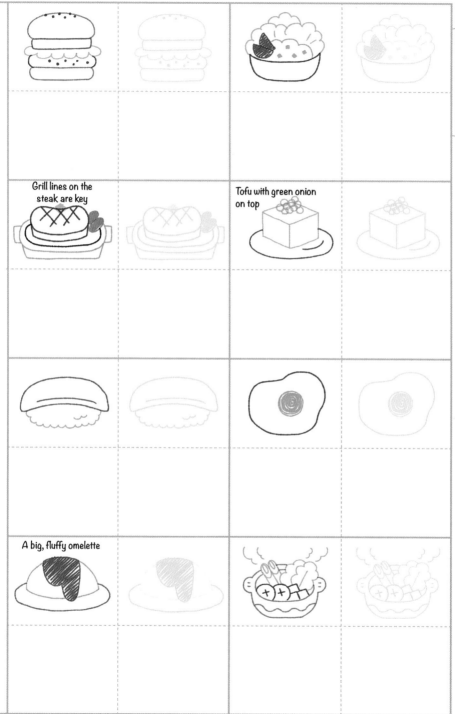

Grill lines on the steak are key

Tofu with green onion on top

A big, fluffy omelette

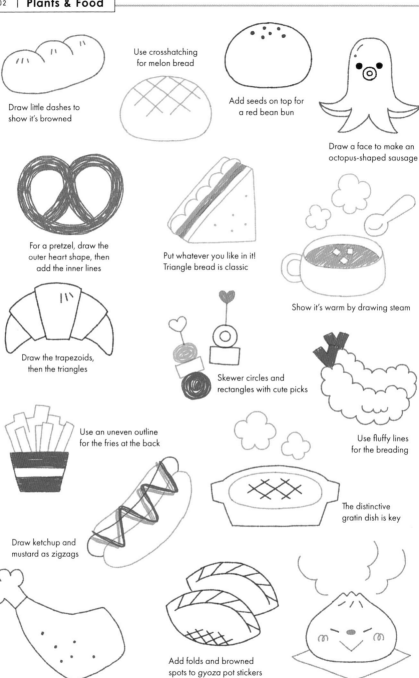

Draw little dashes to show it's browned

Use crosshatching for melon bread

Add seeds on top for a red bean bun

Draw a face to make an octopus-shaped sausage

For a pretzel, draw the outer heart shape, then add the inner lines

Put whatever you like in it! Triangle bread is classic

Show it's warm by drawing steam

Draw the trapezoids, then the triangles

Skewer circles and rectangles with cute picks

Use fluffy lines for the breading

Use an uneven outline for the fries at the back

The distinctive gratin dish is key

Draw ketchup and mustard as zigzags

Give fried chicken a fluffy paper frill

Add folds and browned spots to gyoza pot stickers

Steamed meat buns look cute with a face

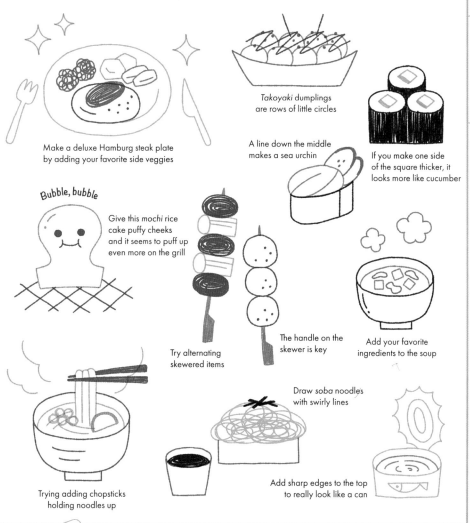

Make a deluxe Hamburg steak plate by adding your favorite side veggies

Takoyaki dumplings are rows of little circles

A line down the middle makes a sea urchin

If you make one side of the square thicker, it looks more like cucumber

Bubble, *bubble*

Give this *mochi* rice cake puffy cheeks and it seems to puff up even more on the grill

Try alternating skewered items

The handle on the skewer is key

Add your favorite ingredients to the soup

Draw *soba* noodles with swirly lines

Trying adding chopsticks holding noodles up

Add sharp edges to the top to really look like a can

NOTE

Tips for illustrating letters

When you're adding illustrations to a card or letter, choose things the recipient likes or a seasonal motif.

She really likes dogs...

Desserts

Lots of desserts have charming shapes, so they're fun to draw.

The shine makes this pudding look yummy

A small circle inside a big circle

Variations!

Dip it in chocolate

Color half pink to make it strawberry-flavored

Draw a brown line to drizzle chocolate on top

Give it a pop-art design

Start with a triangle

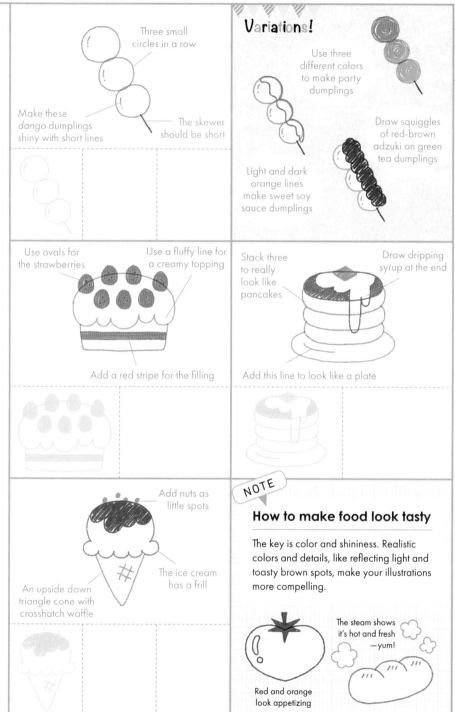

Three small circles in a row

Make these *dango* dumplings shiny with short lines

The skewer should be short

Variations!

Use three different colors to make party dumplings

Draw squiggles of red-brown adzuki on green tea dumplings

Light and dark orange lines make sweet soy sauce dumplings

Use ovals for the strawberries

Use a fluffy line for a creamy topping

Add a red stripe for the filling

Stack three to really look like pancakes

Draw dripping syrup at the end

Add this line to look like a plate

Add nuts as little spots

The ice cream has a frill

An upside down triangle cone with crosshatch waffle

NOTE

How to make food look tasty

The key is color and shininess. Realistic colors and details, like reflecting light and toasty brown spots, make your illustrations more compelling.

The steam shows it's hot and fresh —yum!

Red and orange look appetizing

Start with the triangle

The shine is key

Swirly filling

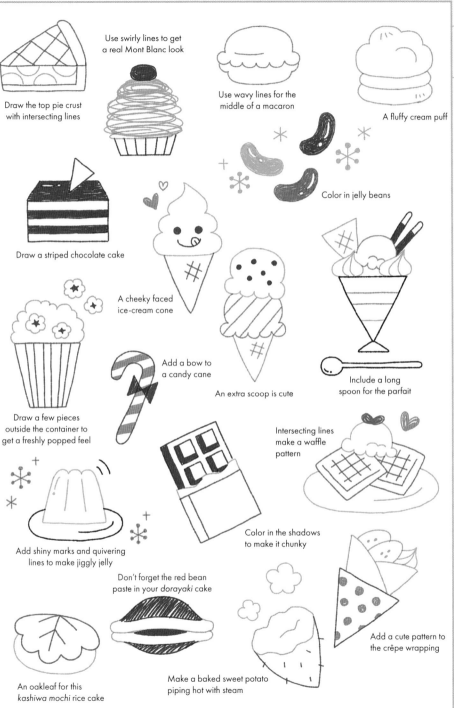

Use swirly lines to get a real Mont Blanc look

Draw the top pie crust with intersecting lines

Use wavy lines for the middle of a macaron

A fluffy cream puff

Color in jelly beans

Draw a striped chocolate cake

A cheeky faced ice-cream cone

An extra scoop is cute

Add a bow to a candy cane

Include a long spoon for the parfait

Draw a few pieces outside the container to get a freshly popped feel

Intersecting lines make a waffle pattern

Color in the shadows to make it chunky

Add shiny marks and quivering lines to make jiggly jelly

Don't forget the red bean paste in your *dorayaki* cake

Add a cute pattern to the crêpe wrapping

An oakleaf for this *kashiwa mochi* rice cake

Make a baked sweet potato piping hot with steam

71

Drinks

Illustrations of drinks are handy when inviting someone out to a café or for cocktails. Draw the glasses in light blue for the right effect.

A squished circle

Make it narrower at the bottom

Variations!

Leave blank squares for ice cubes

Make deluxe OJ by adding a slice of orange

Use tiny circles for bubbles

Draw the foam with fluffy lines

Rounded out at the bottom

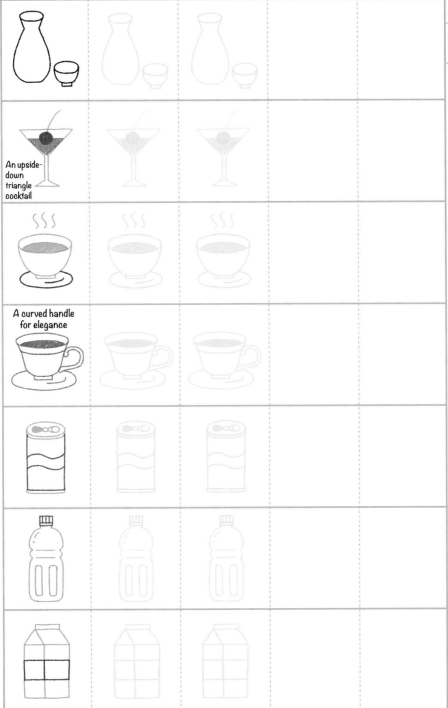

An upside-
down
triangle
cocktail

A curved handle
for elegance

Schedule Icons

★ Illustrate Your Schedule to Add Color to Your Days! ★

SUNDAY	MONDAY	TUESDAY	WEDNESDAY
	1 🎁 Mia's B-day!	2	3 8 p.m. Ⓐ
7 7 p.m. 🤚*	8	9 7 p.m. B Project Wrap Party! 🍺	10 🍴 Noon Lunch with Beth
14 ☕ 11 a.m. Coffee with Mom	15 👛 Payday ♪	16	17 8 p.m. Ⓐ

★ Mini Illustrated Diary ★

Try drawing a picture journal on the weekly pages of your planner ♪

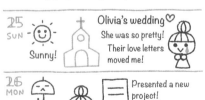

25 SUN	☀ Sunny!	⛪	Olivia's wedding ♡ She was so pretty! Their love letters moved me!
26 MON	☂ Rain	🧍	Presented a new project! I was so nervous.. Hope it gets greenlit ★
27 TUE			

★ Make a Handy Index ★

Put illustrated tabs on pages where you wrote about your favorite restaurants and movies so it's easier to find them later ♪

FAVORITE NOTE

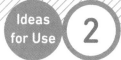

Ideas for Use 2

Scrapbooks

Try writing about things you did and ate that day next to the pictures. It brightens up the pages and makes the memories more fun to look back on.

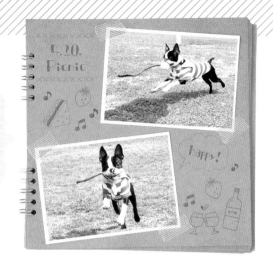

Planner 1

Add some colorful illustrations to the planner you use every day and you'll find yourself feeling life is happier and more fulfilling!

Planner 2

Try keeping a picture journal on the weekly pages of your planner. The key is to write just a couple of notes. Don't overthink it.

Everyday Items

It's fun to try drawing the things you surround yourself with—tools, fashion items, stationery, equipment for interests, and more. This is the easiest theme to customize.

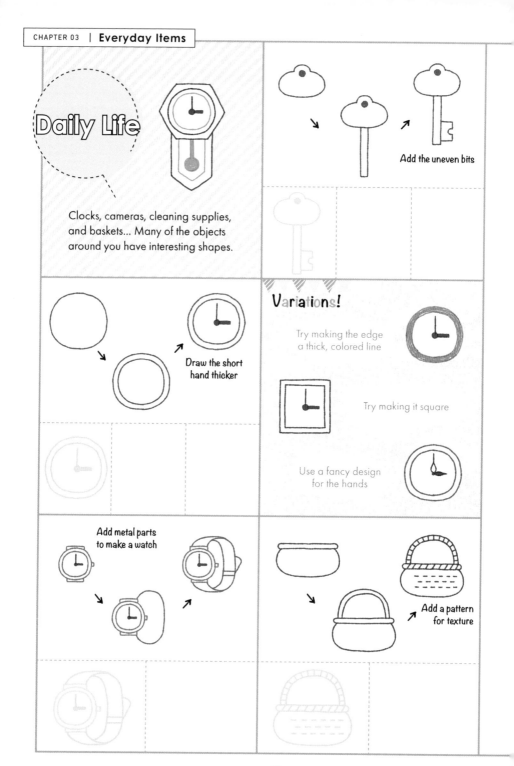

Daily Life

Clocks, cameras, cleaning supplies, and baskets... Many of the objects around you have interesting shapes.

Add the uneven bits

Draw the short hand thicker

Variations!

Try making the edge a thick, colored line

Try making it square

Use a fancy design for the hands

Add metal parts to make a watch

Add a pattern for texture

78

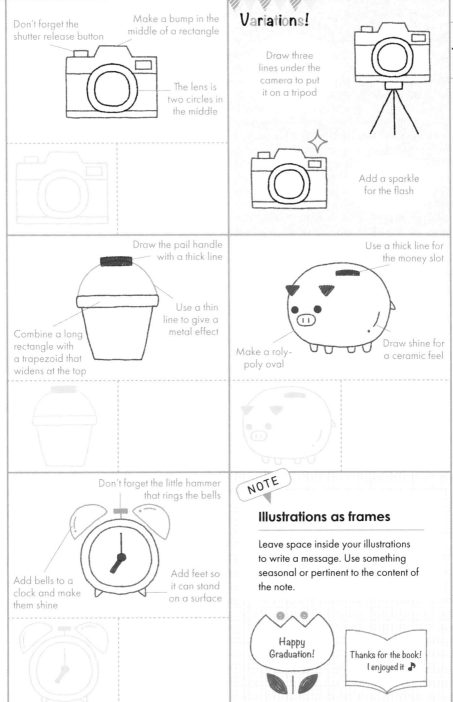

Don't forget the shutter release button

Make a bump in the middle of a rectangle

The lens is two circles in the middle

Variations!

Draw three lines under the camera to put it on a tripod

Add a sparkle for the flash

Draw the pail handle with a thick line

Use a thin line to give a metal effect

Combine a long rectangle with a trapezoid that widens at the top

Use a thick line for the money slot

Make a roly-poly oval

Draw shine for a ceramic feel

Don't forget the little hammer that rings the bells

Add bells to a clock and make them shine

Add feet so it can stand on a surface

NOTE

Illustrations as frames

Leave space inside your illustrations to write a message. Use something seasonal or pertinent to the content of the note.

Happy Graduation!

Thanks for the book! I enjoyed it ♪

A question mark shape

Variations!

Make a pattern with diagonal lines

Polka dots make for a gorgeous gift

Try changing the pattern and ribbon

Draw drops of water

Make the edge of the brush fluffy

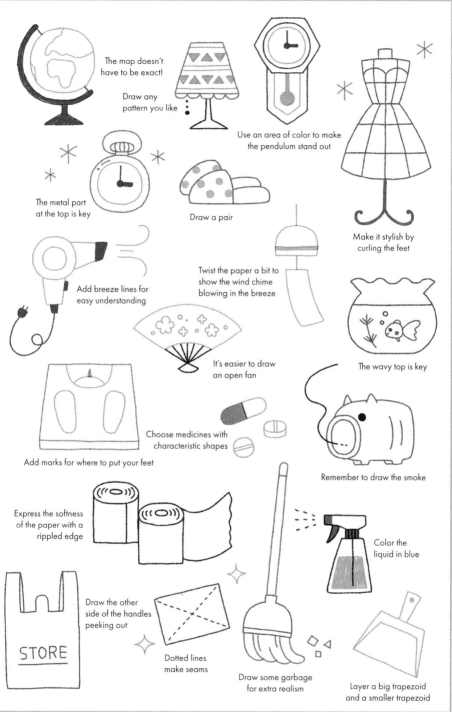

The map doesn't have to be exact!

Draw any pattern you like

Use an area of color to make the pendulum stand out

The metal part at the top is key

Draw a pair

Make it stylish by curling the feet

Add breeze lines for easy understanding

Twist the paper a bit to show the wind chime blowing in the breeze

It's easier to draw an open fan

The wavy top is key

Choose medicines with characteristic shapes

Remember to draw the smoke

Add marks for where to put your feet

Express the softness of the paper with a rippled edge

Color the liquid in blue

STORE

Draw the other side of the handles peeking out

Dotted lines make seams

Draw some garbage for extra realism

Layer a big trapezoid and a smaller trapezoid

81

Dishes & Utensils

Draw the view from the top or the side depending on the object. Pick the angle that is the easiest and cutest.

Matching patterns

A big circle

Variations!

Draw a face. "Yum!"

Trying putting a design around the border

Draw a thick edge thick to add accent

Curve the pattern too

Draw a trapezoid

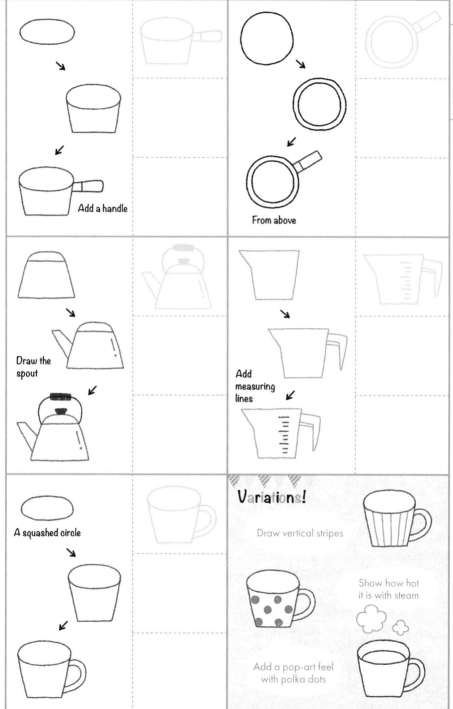

Add a handle

From above

Draw the spout

Add measuring lines

A squashed circle

Variations!

Draw vertical stripes

Add a pop-art feel with polka dots

Show how hot it is with steam

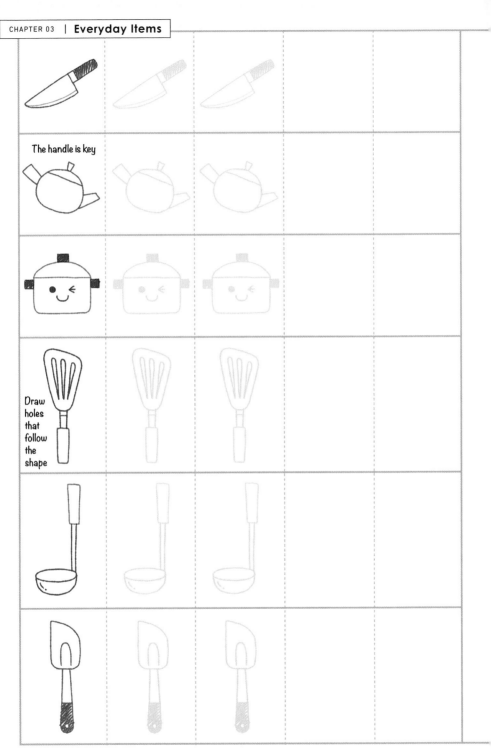

The handle is key

Draw
holes
that
follow
the
shape

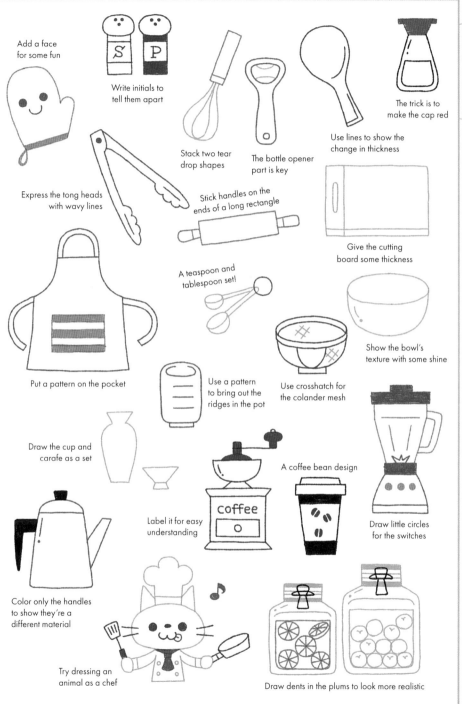

Add a face for some fun

Write initials to tell them apart

The trick is to make the cap red

Use lines to show the change in thickness

Stack two tear drop shapes

The bottle opener part is key

Express the tong heads with wavy lines

Stick handles on the ends of a long rectangle

Give the cutting board some thickness

A teaspoon and tablespoon set!

Show the bowl's texture with some shine

Put a pattern on the pocket

Use a pattern to bring out the ridges in the pot

Use crosshatch for the colander mesh

Draw the cup and carafe as a set

coffee

A coffee bean design

Label it for easy understanding

Draw little circles for the switches

Color only the handles to show they're a different material

Try dressing an animal as a chef

Draw dents in the plums to look more realistic

85

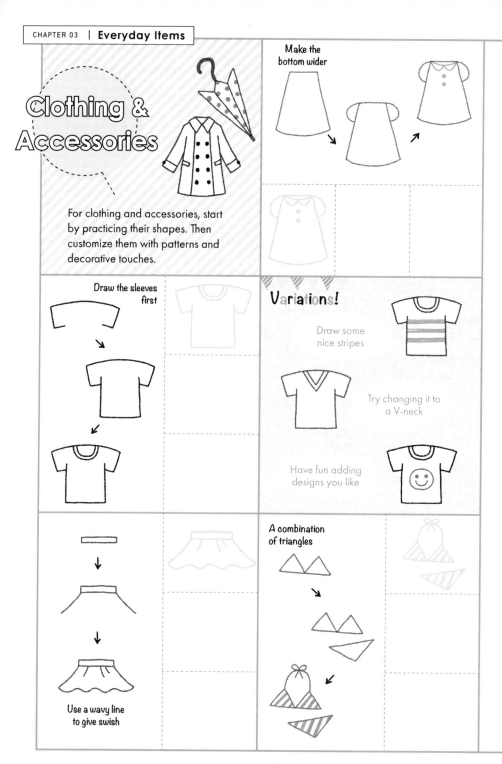

Clothing & Accessories

For clothing and accessories, start by practicing their shapes. Then customize them with patterns and decorative touches.

Make the bottom wider

Draw the sleeves first

Variations!

Draw some nice stripes

Try changing it to a V-neck

Have fun adding designs you like

Use a wavy line to give swish

A combination of triangles

86

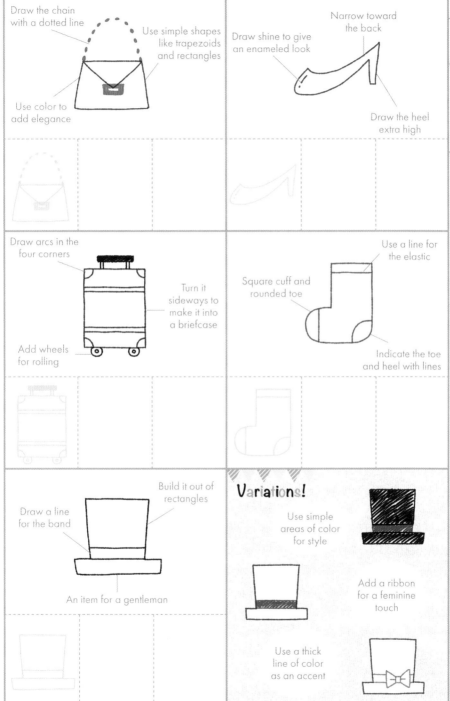

Draw the chain with a dotted line

Use simple shapes like trapezoids and rectangles

Use color to add elegance

Narrow toward the back

Draw shine to give an enameled look

Draw the heel extra high

Draw arcs in the four corners

Turn it sideways to make it into a briefcase

Add wheels for rolling

Use a line for the elastic

Square cuff and rounded toe

Indicate the toe and heel with lines

Draw a line for the band

Build it out of rectangles

An item for a gentleman

Variations!

Use simple areas of color for style

Add a ribbon for a feminine touch

Use a thick line of color as an accent

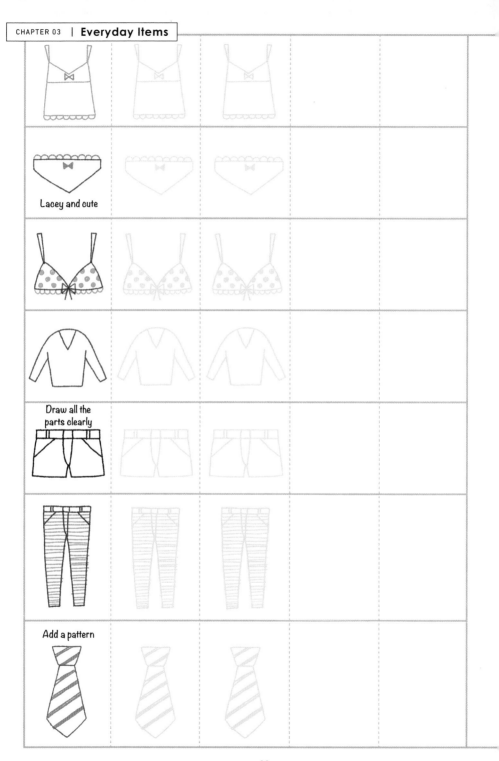

Lacey and cute

Draw all the
parts clearly

Add a pattern

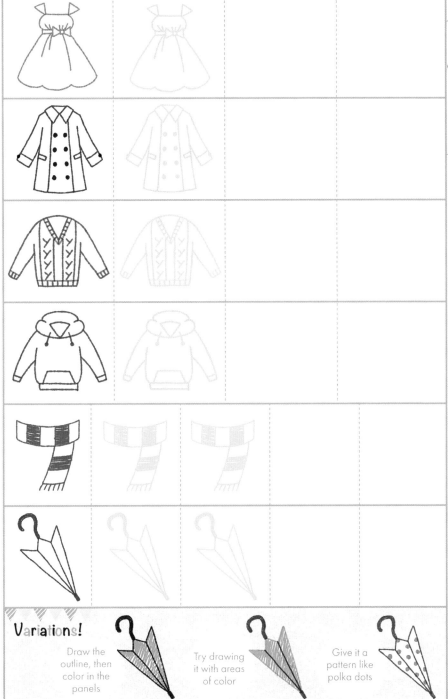

Variations!

Draw the outline, then color in the panels

Try drawing it with areas of color

Give it a pattern like polka dots

Pay attention to
the laces

Variations!

Draw it in
monochrome for a
simple look

Draw a
face for
some fun ♪

Add a
pattern

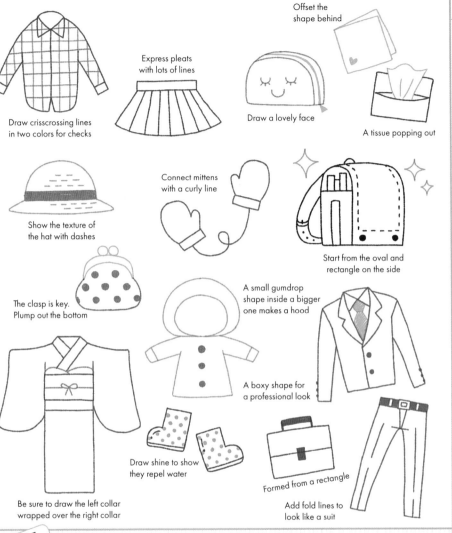

Draw crisscrossing lines in two colors for checks

Express pleats with lots of lines

Offset the shape behind

Draw a lovely face

A tissue popping out

Show the texture of the hat with dashes

Connect mittens with a curly line

Start from the oval and rectangle on the side

The clasp is key. Plump out the bottom

A small gumdrop shape inside a bigger one makes a hood

A boxy shape for a professional look

Draw shine to show they repel water

Formed from a rectangle

Add fold lines to look like a suit

Be sure to draw the left collar wrapped over the right collar

NOTE

Use stick figures and finger puppets for little picture journal entries

When you're drawing in a small space, like in your planner or the gaps in a photo album, try simplifying humans into stick figures and animals into finger puppets. Their actions come across even when they're tiny.

You can label them with their initials so you know who is who.

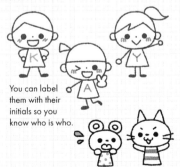

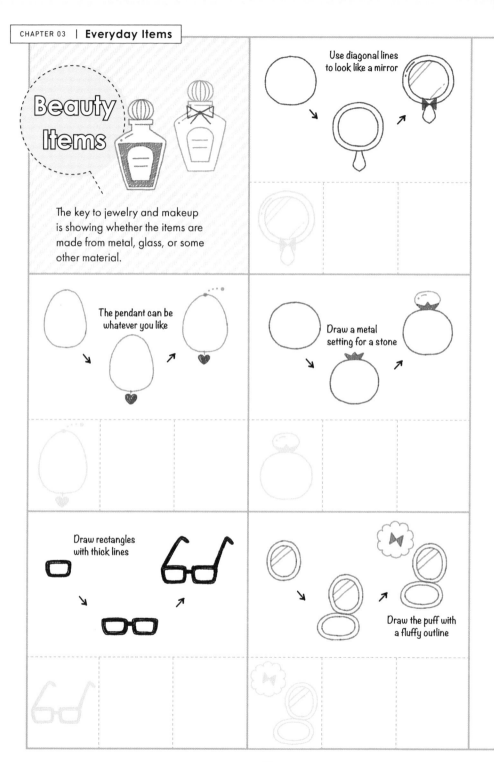

Beauty Items

The key to jewelry and makeup is showing whether the items are made from metal, glass, or some other material.

Use diagonal lines to look like a mirror

The pendant can be whatever you like

Draw a metal setting for a stone

Draw rectangles with thick lines

Draw the puff with a fluffy outline

Make a pair

Variations!

Dress it up
with a ribbon

Try changing
the stopper
shape

Color in the
contents for
extra realism

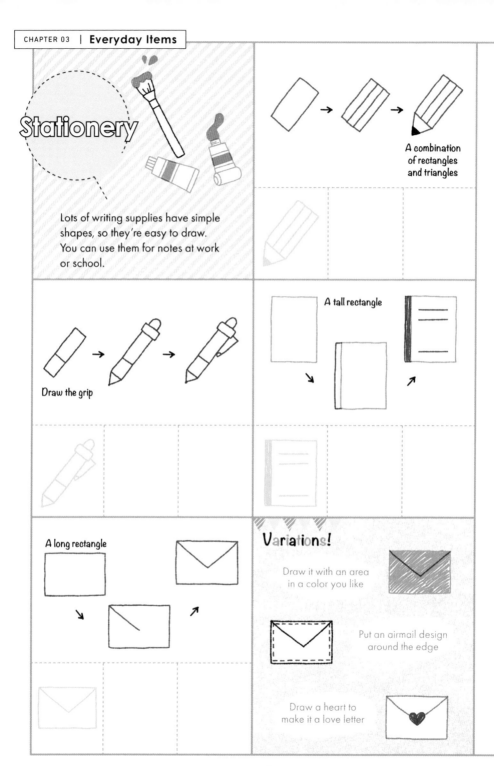

Stationery

Lots of writing supplies have simple shapes, so they're easy to draw. You can use them for notes at work or school.

A combination of rectangles and triangles

Draw the grip

A tall rectangle

A long rectangle

Variations!

Draw it with an area in a color you like

Put an airmail design around the edge

Draw a heart to make it a love letter

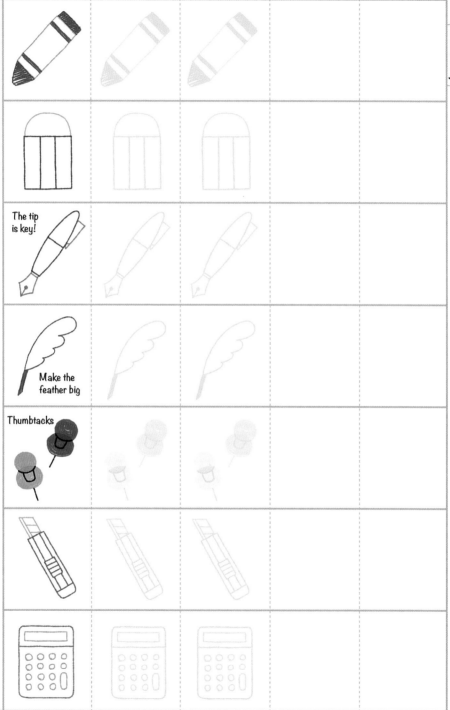

The tip is key!

Make the feather big

Thumbtacks

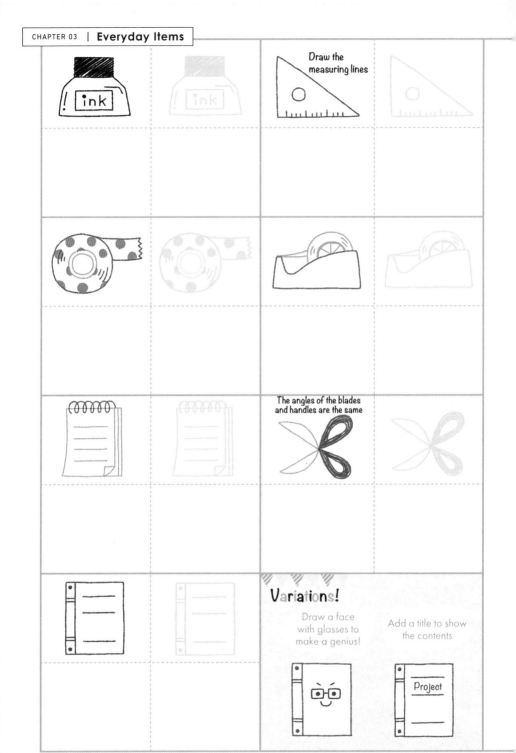

Draw the measuring lines

The angles of the blades and handles are the same

Variations!

Draw a face with glasses to make a genius!

Add a title to show the contents

Project

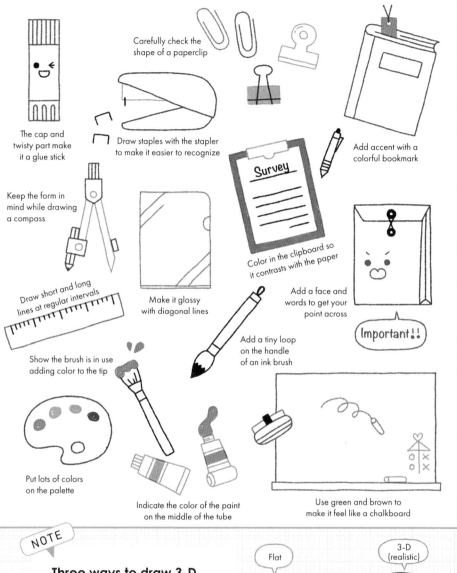

The cap and twisty part make it a glue stick

Carefully check the shape of a paperclip

Draw staples with the stapler to make it easier to recognize

Add accent with a colorful bookmark

Keep the form in mind while drawing a compass

Survey

Color in the clipboard so it contrasts with the paper

Make it glossy with diagonal lines

Draw short and long lines at regular intervals

Add a face and words to get your point across

Important!!

Show the brush is in use adding color to the tip

Add a tiny loop on the handle of an ink brush

Put lots of colors on the palette

Indicate the color of the paint on the middle of the tube

Use green and brown to make it feel like a chalkboard

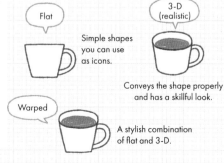

NOTE

Three ways to draw 3-D objects

By drawing depth and height, you can add dimension to your illustrations. When your goal is simplicity, draw flat. When you really want to convey something's shape, draw in 3-D.

Flat

Simple shapes you can use as icons.

3-D (realistic)

Conveys the shape properly and has a skillful look.

Warped

A stylish combination of flat and 3-D.

Toys

From simple balloons and garlands to more intricate dolls and robots—it's playtime.

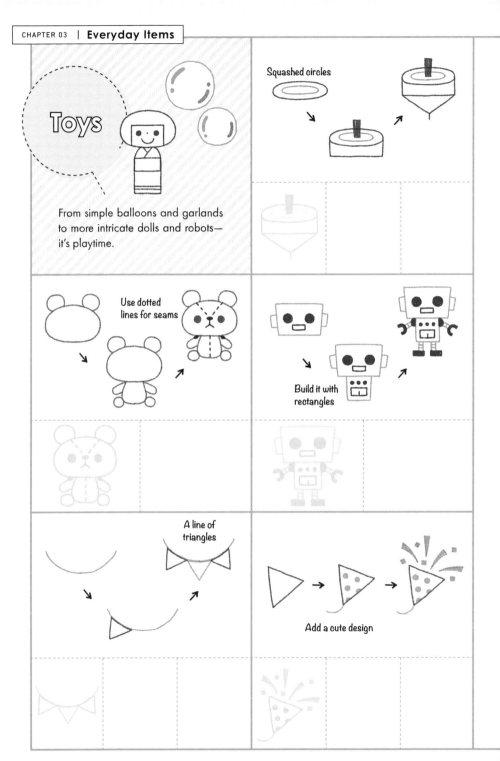

Squashed circles

Use dotted lines for seams

Build it with rectangles

A line of triangles

Add a cute design

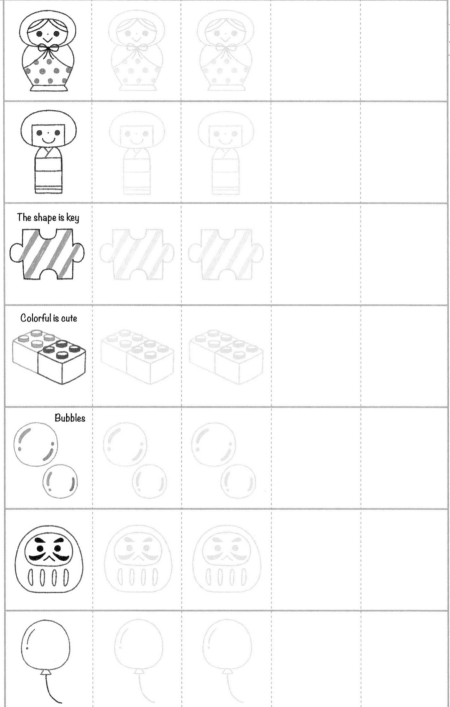

The shape is key

Colorful is cute

Bubbles

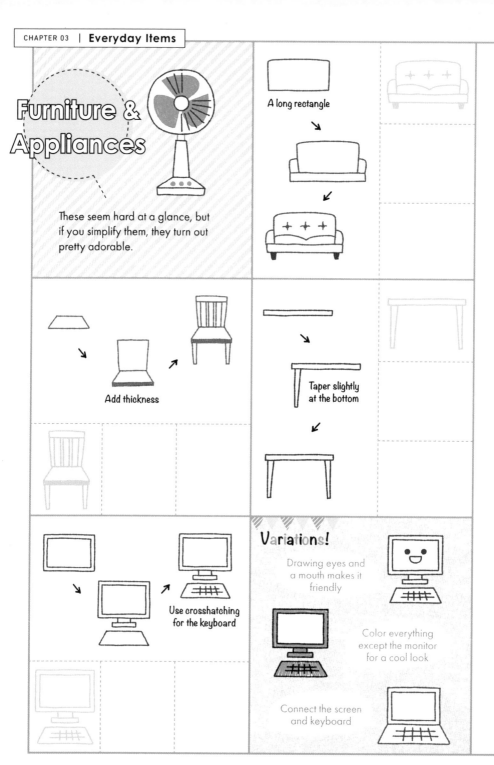

Furniture & Appliances

These seem hard at a glance, but if you simplify them, they turn out pretty adorable.

A long rectangle

Add thickness

Taper slightly at the bottom

Use crosshatching for the keyboard

Variations!

Drawing eyes and a mouth makes it friendly

Color everything except the monitor for a cool look

Connect the screen and keyboard

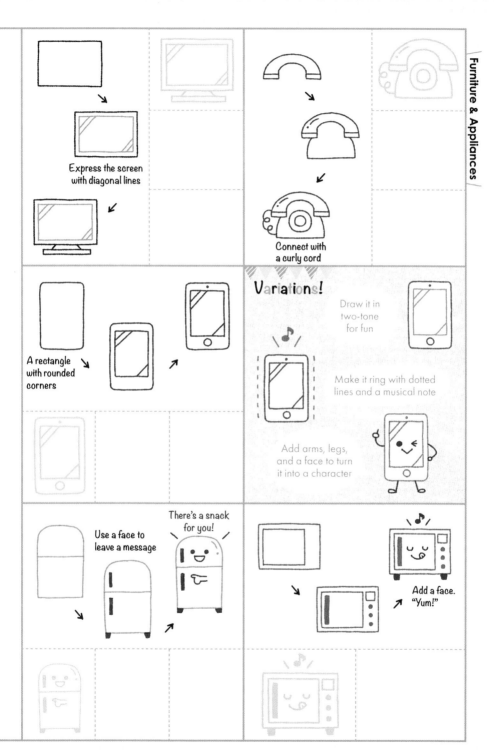

Express the screen with diagonal lines

Connect with a curly cord

A rectangle with rounded corners

Variations!

Draw it in two-tone for fun

Make it ring with dotted lines and a musical note

Add arms, legs, and a face to turn it into a character

Use a face to leave a message

There's a snack for you!

Add a face. "Yum!"

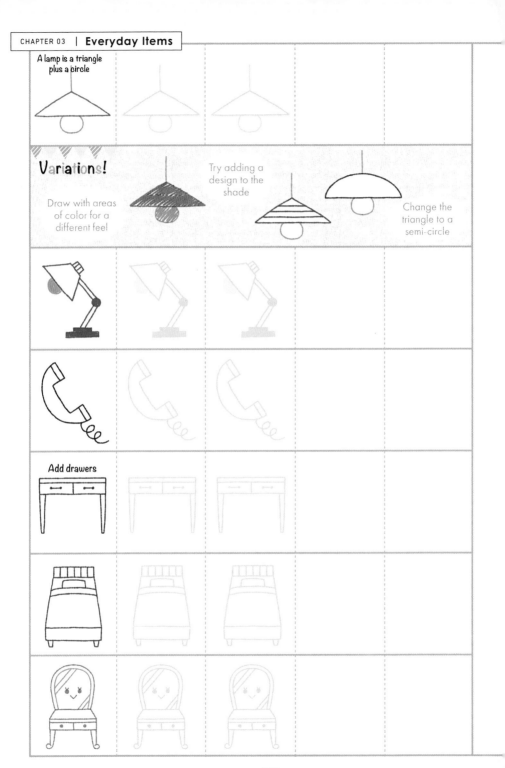

A lamp is a triangle plus a circle

Variations!

Draw with areas of color for a different feel

Try adding a design to the shade

Change the triangle to a semi-circle

Add drawers

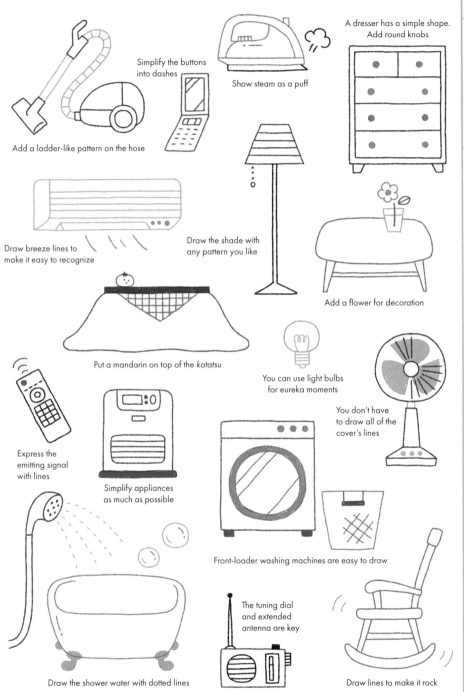

Add a ladder-like pattern on the hose

Simplify the buttons into dashes

Show steam as a puff

A dresser has a simple shape. Add round knobs

Draw breeze lines to make it easy to recognize

Draw the shade with any pattern you like

Add a flower for decoration

Put a mandarin on top of the *kotatsu*

You can use light bulbs for eureka moments

You don't have to draw all of the cover's lines

Express the emitting signal with lines

Simplify appliances as much as possible

Front-loader washing machines are easy to draw

Draw the shower water with dotted lines

The tuning dial and extended antenna are key

Draw lines to make it rock

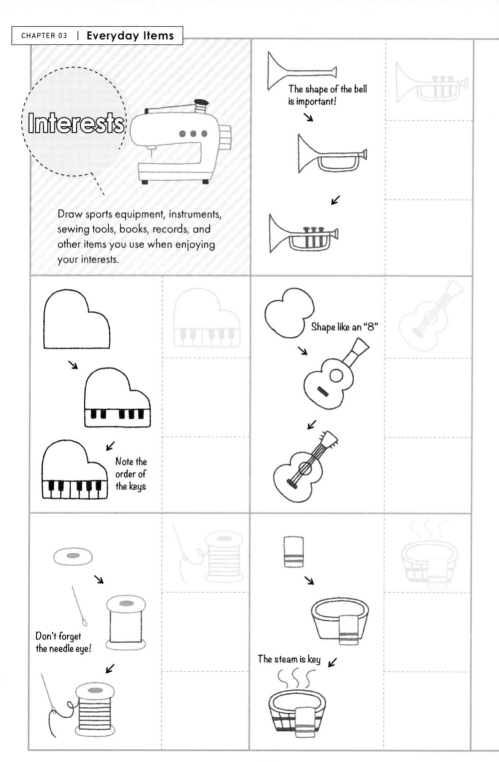

Interests

Draw sports equipment, instruments, sewing tools, books, records, and other items you use when enjoying your interests.

The shape of the bell is important!

Note the order of the keys

Shape like an "8"

Don't forget the needle eye!

The steam is key

Connect the corners with lines

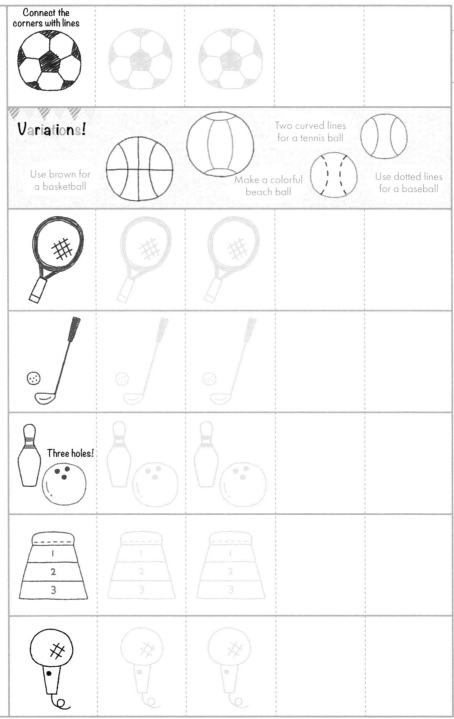

Variations!

Use brown for a basketball

Make a colorful beach ball

Two curved lines for a tennis ball

Use dotted lines for a baseball

Three holes!

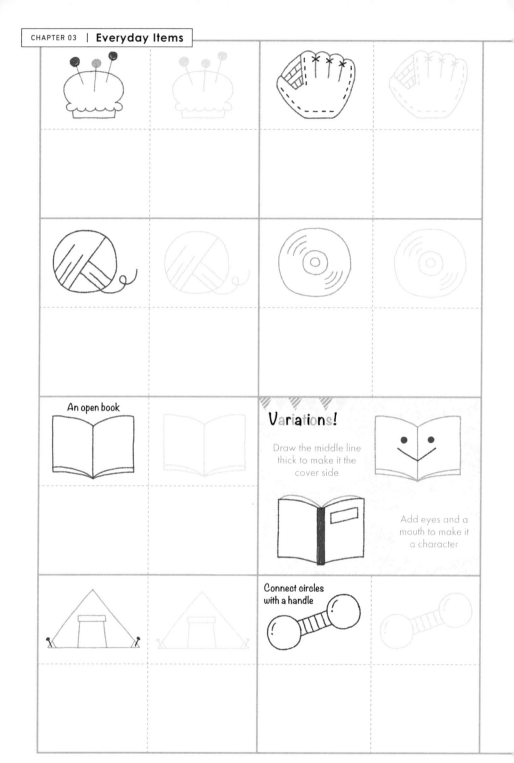

An open book

Variations!

Draw the middle line thick to make it the cover side

Add eyes and a mouth to make it a character

Connect circles with a handle

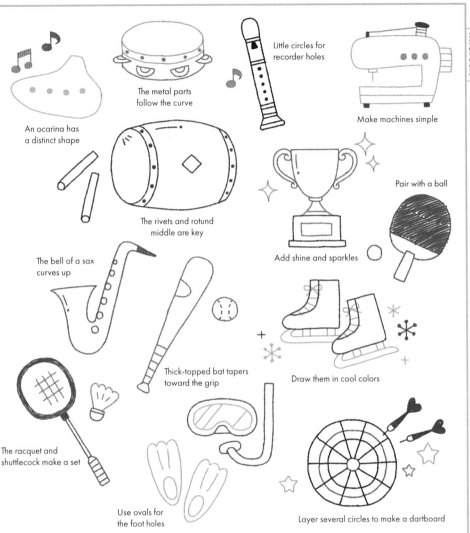

Little circles for recorder holes

The metal parts follow the curve

Make machines simple

An ocarina has a distinct shape

The rivets and rotund middle are key

Pair with a ball

Add shine and sparkles

The bell of a sax curves up

Thick-topped bat tapers toward the grip

Draw them in cool colors

The racquet and shuttlecock make a set

Use ovals for the foot holes

Layer several circles to make a dartboard

NOTE

Emphasize parts by drawing them bigger

An effective way to emphasize something—a peace sign, a heart to say "I love you," glistening eyes—is to draw it big. That way it stands out, and your feelings will come across that much more.

Please...!

Draw things bigger or exaggerate expressions.

Seasonal Illustrations

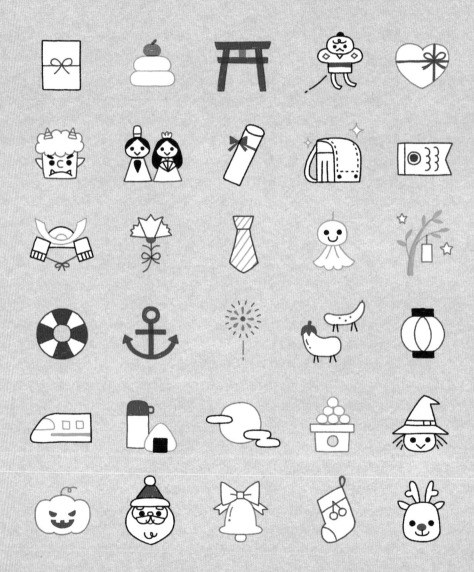

★ Drawing Your Plans ★

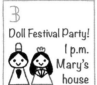
3
Doll Festival Party!
1 p.m.
Mary's house

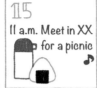
15
11 a.m. Meet in XX for a picnic ♪

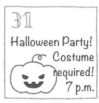
31
Halloween Party! Costume required! 7 p.m.

24
Xmas ☆ ☆ Party! My house 12 noon

★ In an Album ★

Liven it up with illustrations ♪

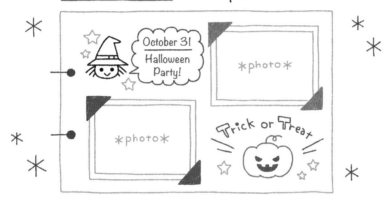

October 31 Halloween Party!

photo

photo

Trick or Treat

★ When You Give Someone Photos ★

Draw illustrations on the envelope to make it a gift...

Dear Abby,

Here are the Xmas Party photos ♪ What a great time we had!

When you give them data on a CD...

Put an illustration on the label so you can tell what it is at a glance ♪

September 7, 20XX Ethan's First Day of School

Bookmarks

Draw an animal and cut its body shape at the top and bottom. Add a ribbon tail and have it lounge in your book as a cute bookmark.

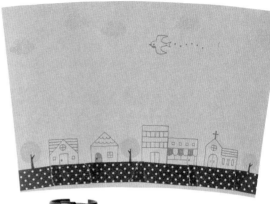

Tumblers

Get a tumbler that has a removable insert and create your own custom designs. Have a fun coffee break.

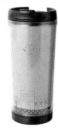

Paper Bags

Draw a ribbon or other design directly onto the bag. This is great for giving a gift or returning something you borrowed.

Book Covers

Draw borders along the top and bottom plus a single cute illustration in the middle. You'll love carrying around a book with your original cover on it!

⇩

And More!

Buildings and vehicles, scenery, weather... When you look out your window, there are tons of inspiring motifs to draw. Definitely practice the unique Fun Drawings included here too.

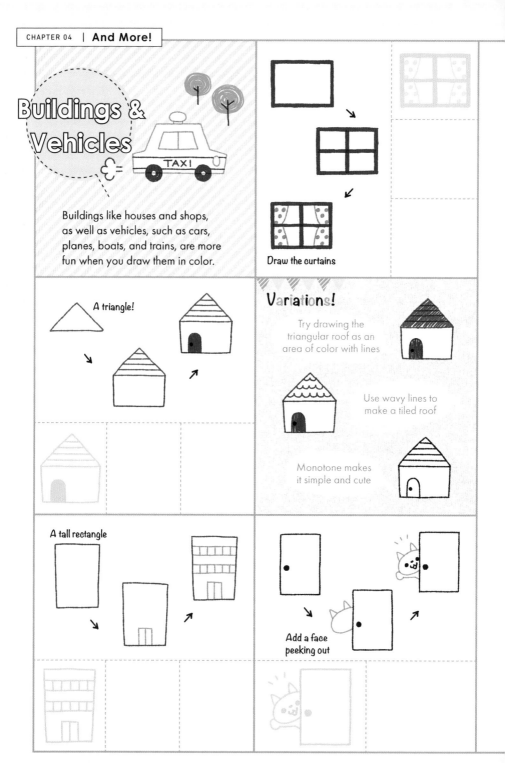

Buildings & Vehicles

TAXI

Buildings like houses and shops, as well as vehicles, such as cars, planes, boats, and trains, are more fun when you draw them in color.

Draw the curtains

A triangle!

Variations!

Try drawing the triangular roof as an area of color with lines

Use wavy lines to make a tiled roof

Monotone makes it simple and cute

A tall rectangle

Add a face peeking out

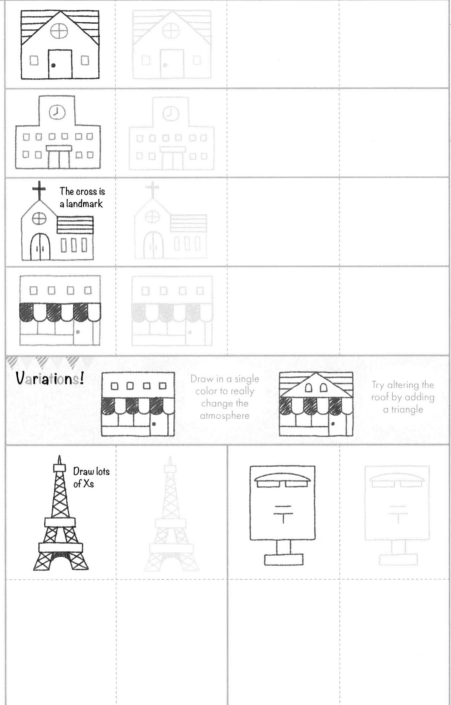

The cross is a landmark

Variations!

Draw in a single color to really change the atmosphere

Try altering the roof by adding a triangle

Draw lots of Xs

113

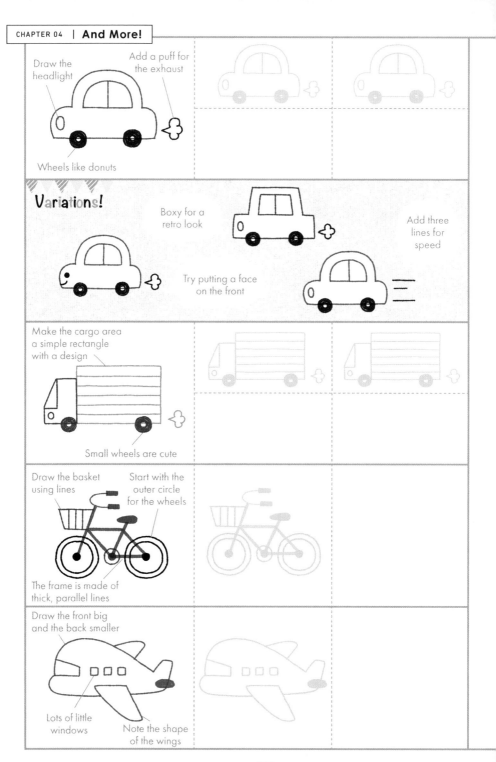

Draw the headlight

Add a puff for the exhaust

Wheels like donuts

Variations!

Boxy for a retro look

Add three lines for speed

Try putting a face on the front

Make the cargo area a simple rectangle with a design

Small wheels are cute

Draw the basket using lines

Start with the outer circle for the wheels

The frame is made of thick, parallel lines

Draw the front big and the back smaller

Lots of little windows

Note the shape of the wings

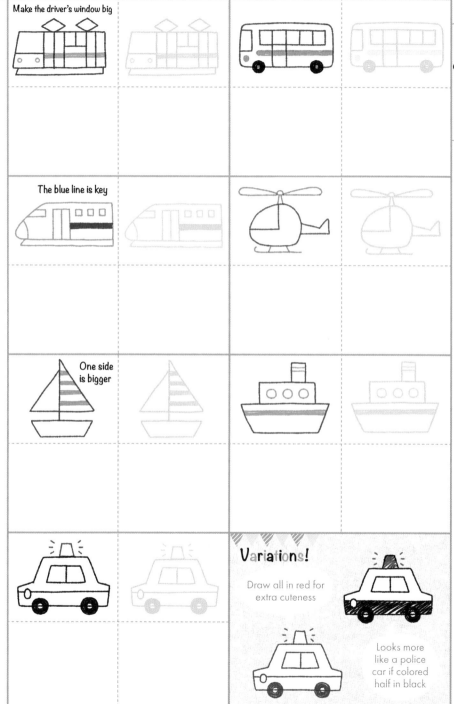

Make the driver's window big

The blue line is key

One side is bigger

Variations!

Draw all in red for extra cuteness

Looks more like a police car if colored half in black

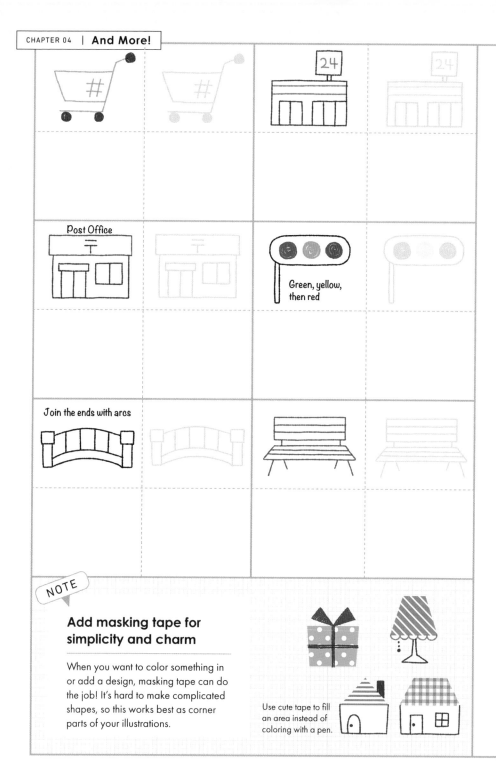

Post Office

Green, yellow, then red

Join the ends with arcs

NOTE

Add masking tape for simplicity and charm

When you want to color something in or add a design, masking tape can do the job! It's hard to make complicated shapes, so this works best as corner parts of your illustrations.

Use cute tape to fill an area instead of coloring with a pen.

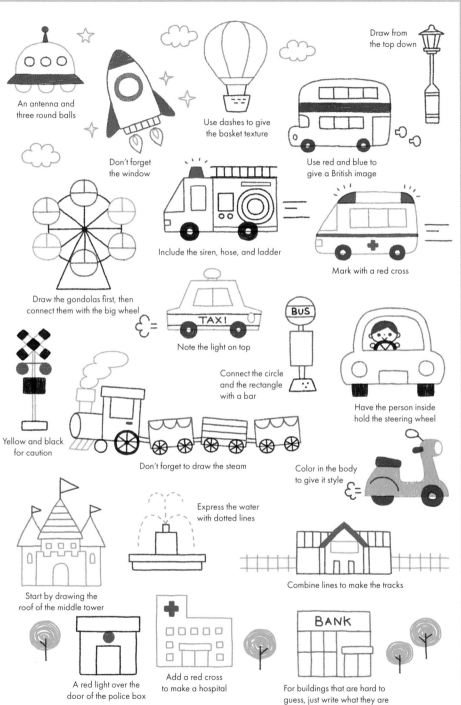

An antenna and three round balls

Don't forget the window

Use dashes to give the basket texture

Draw from the top down

Use red and blue to give a British image

Draw the gondolas first, then connect them with the big wheel

Include the siren, hose, and ladder

Mark with a red cross

Note the light on top

Connect the circle and the rectangle with a bar

Have the person inside hold the steering wheel

Yellow and black for caution

Don't forget to draw the steam

Color in the body to give it style

Express the water with dotted lines

Combine lines to make the tracks

Start by drawing the roof of the middle tower

A red light over the door of the police box

Add a red cross to make a hospital

BUS

TAXI

BANK

For buildings that are hard to guess, just write what they are

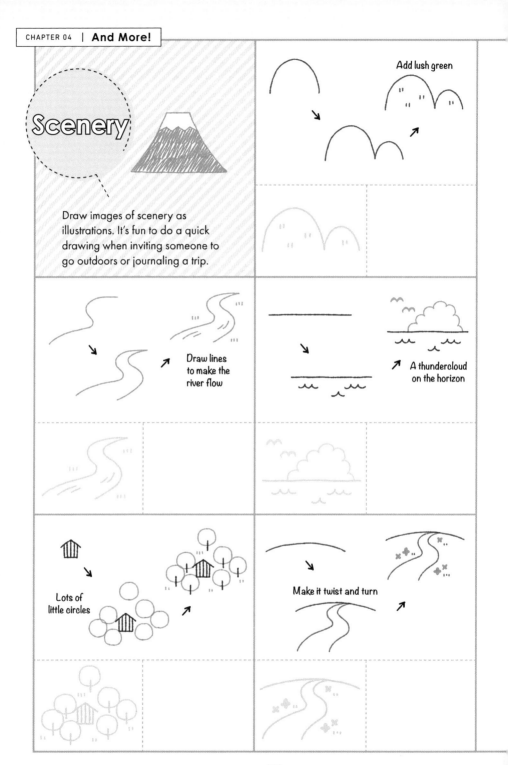

Scenery

Draw images of scenery as illustrations. It's fun to do a quick drawing when inviting someone to go outdoors or journaling a trip.

Add lush green

Draw lines to make the river flow

A thundercloud on the horizon

Lots of little circles

Make it twist and turn

The pattern on top is key

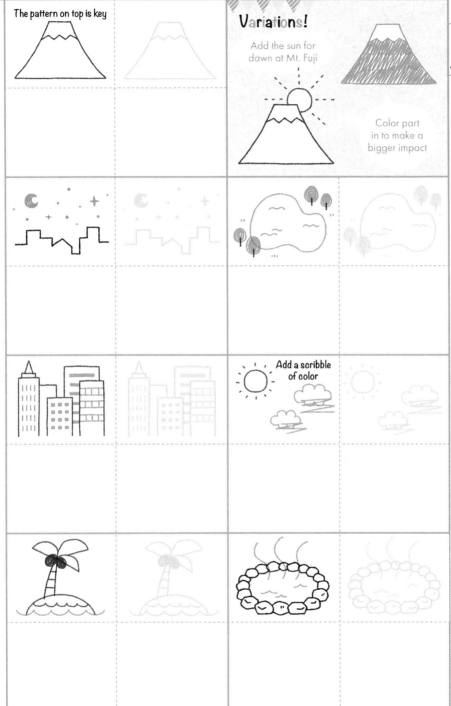

Variations!

Add the sun for dawn at Mt. Fuji

Color part in to make a bigger impact

Add a scribble of color

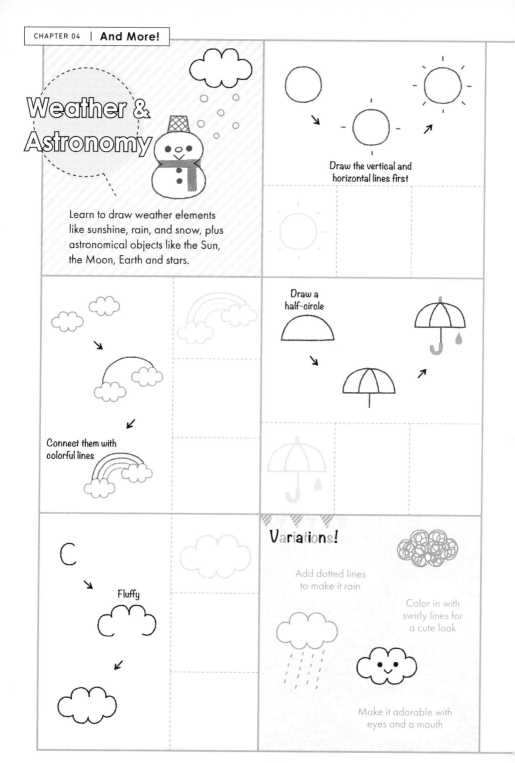

Weather & Astronomy

Learn to draw weather elements like sunshine, rain, and snow, plus astronomical objects like the Sun, the Moon, Earth and stars.

Draw the vertical and horizontal lines first

Connect them with colorful lines

Draw a half-circle

C

Fluffy

Variations!

Add dotted lines to make it rain

Color in with swirly lines for a cute look

Make it adorable with eyes and a mouth

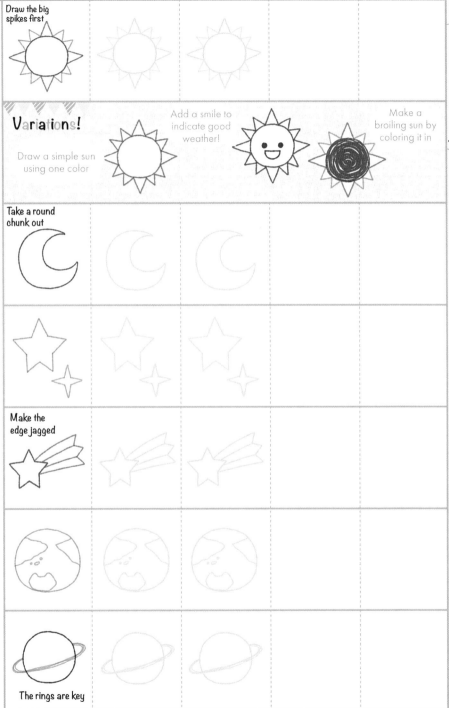

Draw the big spikes first

Variations!

Draw a simple sun using one color

Add a smile to indicate good weather!

Make a broiling sun by coloring it in

Take a round chunk out

Make the edge jagged

The rings are key

A cloud first,
then the sun

Draw it zig-zag

Variations!

Color the hat
for accent

Lovely all in
one single
color, too

Dress it up
with a scarf

A sparkling crystal

Strong wind!

122

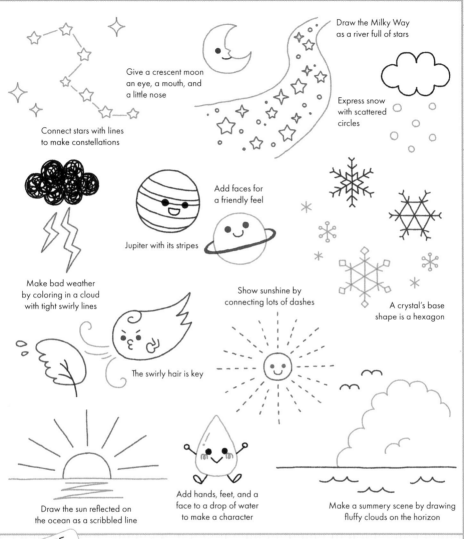

Connect stars with lines to make constellations

Give a crescent moon an eye, a mouth, and a little nose

Draw the Milky Way as a river full of stars

Express snow with scattered circles

Make bad weather by coloring in a cloud with tight swirly lines

Jupiter with its stripes

Add faces for a friendly feel

A crystal's base shape is a hexagon

The swirly hair is key

Show sunshine by connecting lots of dashes

Draw the sun reflected on the ocean as a scribbled line

Add hands, feet, and a face to a drop of water to make a character

Make a summery scene by drawing fluffy clouds on the horizon

NOTE

What to do with extra space

"The main illustration is done, but it looks kind of lonely..." At times like these, decorations and mini motifs can help you out! Liven up the areas around your main drawing.

You can decorate the top and bottom with borders.

Use mini motifs like hearts, stars, or sparkles.

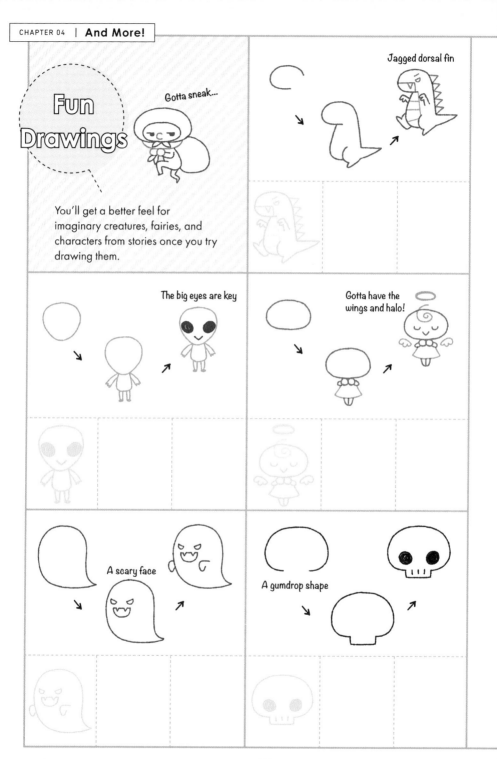

Fun Drawings

Gotta sneak...

You'll get a better feel for imaginary creatures, fairies, and characters from stories once you try drawing them.

Jagged dorsal fin

The big eyes are key

Gotta have the wings and halo!

A scary face

A gumdrop shape

A kappa needs a plate on its head!

Borders & Decorations

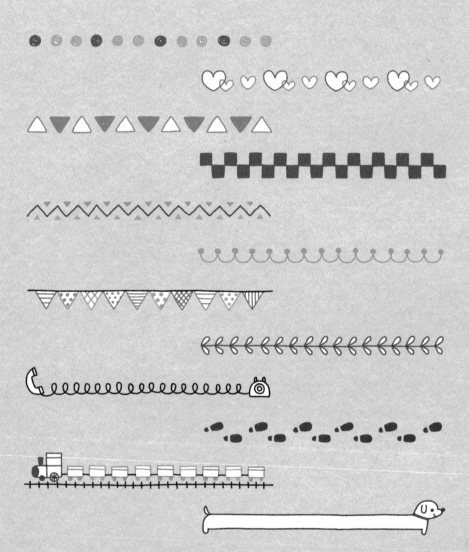

★ On Handmade Cards ★

Make cute, simple cards
by drawing
borders
along the top
and bottom♪

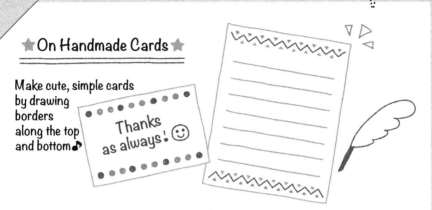

Thanks
as always! ☺

★ Use as Encircling Borders ★

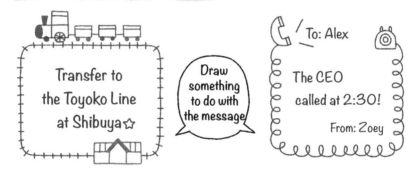

Transfer to
the Toyoko Line
at Shibuya☆

Draw
something
to do with
the message

To: Alex

The CEO
called at 2:30!

From: Zoey

★ Attached to a Gift ★

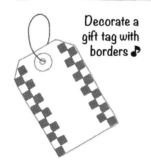

Decorate a
gift tag with
borders ♪

★ For Extended Plans ★

	11	2	3
	Spot is visiting		
7	8	9	10
Chilling in Kyoto!			
14	15	16	

Yooco Takashima

Illustrator living in Tokyo. Graduate of the
Department of Design, Joshibi University of Art
and Design. After working at a web design firm
and as a designer for a company making lifestyle
goods, she became a freelance illustrator in the
summer of 2011. Her art can be found in a wide
variety of places including women and children's
magazines, books, and on stationery, everyday
objects, websites, and more.
Find out more on her website: http://nicotte.com

Cute Drawings: 474 Fun Exercises to Draw Everything Cuter
by Yooco Takashima

Published in 2018 by:
NIPPAN IPS Co., Ltd.
1-3-4 Yushima, Bunkyo-ku
Tokyo, 113-0034, JAPAN

ISBN 978-4-86505-140-7

KAKIKOMISHIKI KAWAII BORUPEN IRASUTO RENSHUCHO
© SEIBIDO SHUPPAN 2015
Original Japanese edition is published by SEIBIDO SHUPPAN Co., Ltd.

Design: Mari Sakuma (3Bears)
Photography: Naoko Honma
Editorial Support: Satomi Obata
Editing: Seibido Shuppan Editorial Dept. (Yuko Kawakami)
Translation: Emily Balistrieri
Thanks to TIME & SPACE, INC. for help with translation
http://www.timeandspace.jp

Printed in China